Take It Easy
PORTLAND IN THE 1970s

JOHN DUNCAN
9-15-2022

ENJOY!!

Take It Easy
PORTLAND IN THE 1970s

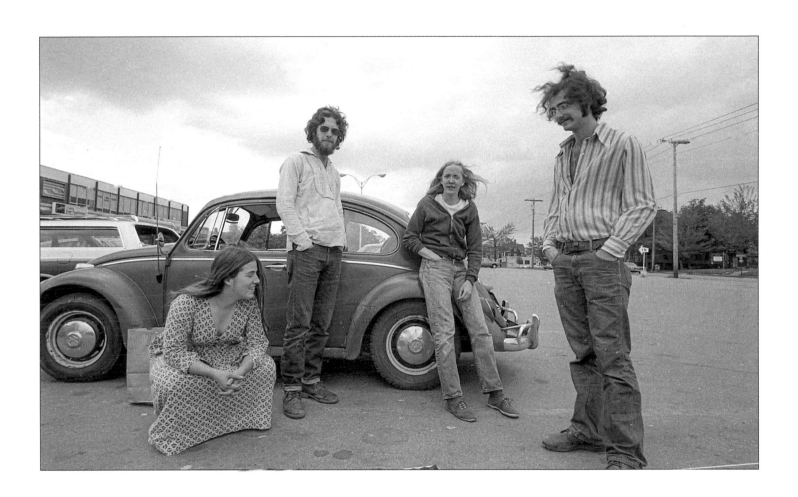

By John Duncan

ISLANDPORT PRESS

ISLANDPORT PRESS

Islandport Press
P.O. Box 10
247 Portland Street
Yarmouth, Maine 04096
www.islandportpress.com
info@islandportpress.com

ISBN: 978-1-952143-20-5
Library of Congress Card Number: 2021935325

Dean L. Lunt, publisher
Teresa Lagrange, book designer
Printed in the USA.

For Susanne, Joel, and Leo

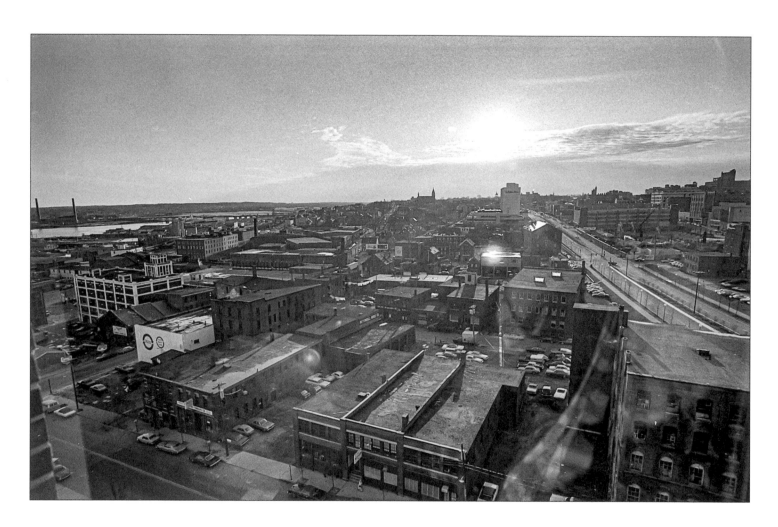

An aerial view of Portland looking up the recently widened Spring Street toward the Holiday Inn by the Bay. In the upper right you can see the construction site for the Cumberland County Civic Center, which brought a major change in size and scope of entertainment for the city of Portland, which had been dominated by small clubs and local bands. The first headline act to play the new arena was ZZ Top on March 3, 1977.

Table of Contents

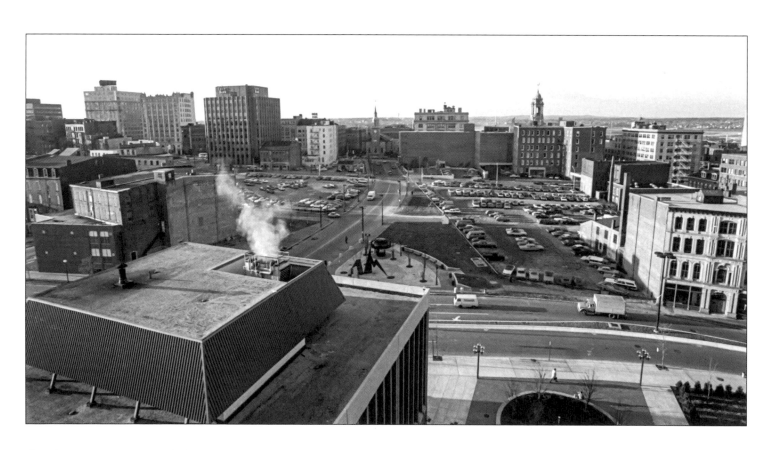

The view looking up Temple Street from Middle Street shows how the area has changed since the 1970s. Where you can see the surface parking lot to the left was an area popularly known as The Golden Triangle. It was flanked by Middle Street, Federal Street, and Temple Street. By 1973, all the old buildings in the Triangle had been demolished as part of urban renewal. In that spot, a much taller office building, One City Center, was completed in 1985. The surface parking to the right is now mostly a parking garage and the Nickelodeon Theater.

Foreword

By Dean L. Lunt

I have worked as a journalist, writer, and editor for more than three decades. On any given day hundreds, perhaps thousands, of images and stories and proposals flicker across my screen or slide across my desk. A lot of noise. A lot of sameness.

Last year, a black-and-white image more than forty years old broke through that noise. The photograph, which appeared in a newspaper article, shows two elderly women in hats and long coats walking toward each other, stone-faced and purposeful, on the streets of Portland, Maine, in the 1970s. The backdrop is the now-closed State Drug at State and High streets. The image jumped up and grabbed at me. It was different. It was fascinating.

The photographer was John Duncan and when he snapped that picture, he was a twenty-something free spirit with no formal photographic training, but nursing an obsession with the art form. He lived in Portland and paid the bills by picking up a few odd jobs, but mostly he drove a taxi and washed dishes at local restaurants.

After I tracked him down, he began sending me links to more and more of his images from the seventies. What he showcased—in sometimes chaotic bursts—over the following weeks grew into a remarkable body of work, an intoxicating mix of street photography, candid photos, and personal images. His photography captured a time and place with a vibe I had never seen about a Maine city or town. In New York? Perhaps. In Maine? No.

Most of the pictures—and he took thousands—Duncan had forgotten about in the haze of time and travel and work. But nearly fifty years later and retired, he was joyously rediscovering his passion and his past by digitally scanning the old film negatives. He shared a handful of the images on social media to great applause and triggered a kind of communal explosion of memories from people who inhabited that space and time with him so long ago.

Overall, the sheer volume of photographs, the compressed timeline (1972-1979), and the unusually concentrated location—essentially Congress Street in the midst of its epic fall from grace—combine to create an eye-opening collection of images that paint a rare close-up of a living, breathing city buffeted by change and uncertainty. Here in black-and-white was joy and pain and melancholy as it played out in real time on the streets of a city that, in many ways, is unrecognizable from the wealthier, trendier, hipster-infused tourist town that so many love today. In the 1970s, *GQ* magazine would not have tabbed the downtown Portland seen through Duncan's lens as one of the coolest cities in America. But in many ways it seems more real —almost like Kodachrome vs. CGI.

The look and feel of Duncan's photos give off whiffs of old *Rolling Stone* magazine images and Alfred Wertheimer's legendary candids of a young Elvis. Closer to home, they echo the work of the brilliant Kosti Ruohomaa, only Duncan replaces images of the farms, work boats, and rural kitchens of 1950s Maine with the grittier city sidewalks and cheap apartments on a half-mile strip of 1970s Congress Street and its adjacent neighborhoods. Duncan's photos are less shadowed and dramatically lit, and may be less "professional" than Ruohomaa, but like Ruohomaa's Maine work, Duncan's are not epic. They are not of famous people, places, events, or disasters; rather they record and elevate a simple, daily life that, even if unknowingly to the subjects at the time, is threatened by unrelenting and irreversible change.

John Duncan is still photographing Portland. As he did then, when Duncan shoots his subjects, he opens a window to the world he sees in front of him. Shadows and light. Slight blurs in motion. Cluttered backgrounds. He uses no tricks, just a simple camera and a good eye to deliver images that are often

intimate, inviting, and presented in a way that draws you in and you linger. For a moment, you may forget you are looking at a photo, or a piece of history. Instead, you become part of the photo. It feels as if you are there, in the frame. Duncan's friends are your friends, hanging out in your apartment. You see his friends or subjects and wonder, "What are they doing?" You notice the surroundings and see the bottle of Old Milwaukee on the side table, or the pack of cigarettes, a boy's sideways glance, a hairbrush, or a billboard high above Congress Street.

A deeper appreciation of what Duncan has accomplished—external from the images themselves—can be gained by understanding two key elements: the iconic nature of this particular time and place, and Duncan himself (the author's note on page xiii offers fascinating insight). The captions and essays he has written in this book build critical context and form a narrative arc that tells a larger story of downtown Portland.

Duncan was a full-blooded child of the seventies. He grew up living a fairly routine life in Falmouth, graduated from high school in 1969, immediately moved to Portland, attended Woodstock that summer, dropped acid in the woods of Max Yasgur's farm, and emerged as an unmoored soul fueled by curiosity and a thirst for experiences. He might drop everything in a finger-snap for a cross-country hitchhiking adventure with a friend—or even a stranger. He lived in the moment. If he ran out of money on the road, he'd sell his motorcycle or his camera so he could eat, or he'd pick up a job wherever necessary, which

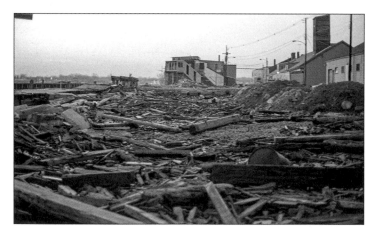

This picture shows the demolition of the former Central Wharf, at the current site of Chandler's Wharf and Long Wharf, on the Portland waterfront. DiMillo's restaurant is now located at left. The demolition took place in 1975 and the debris was cleared.

might mean shoveling mud at a Wyoming oil rig, pumping gas at a truck stop, or cooking at a school with ties to Scientology. When he stashed away enough cash or the urge struck him, he moved on. What he never did, and never has done, is work as a paid photographer.

While unmoored in an existential sense, Duncan remained anchored to Portland, more specifically the evolving downtown. His young-adult life daily took him out to the streets of a city facing its own existential crisis. The city was trying to find a future even as its past was crumbling like so much falling brick, whether from neglect or a wrecking ball. He drove a cab, washed dishes, collected trash, lived in cheap apartments, drank, listened to music, and took drugs. His jobs, his lifestyle, and his insatiable curiosity—the single greatest trait for any journalist or photographer—gave him the time, access, and drive to snap thousands of pictures whenever he had a camera. His natural empathy infused those photos with life, while his innate ability to frame and compose shots on the fly gave them his signature quality.

Duncan's personality and style certainly lent themselves to capturing candid moments. I work with top photographers who sometimes spend endless time lighting a shot, manipulating the background, or waiting for the perfect moment. Duncan often took shots without breaking stride. He could whip out his camera and shoot as quickly as a Wild West gunfighter. Unlike a documentary photographer who might airdrop onto the streets for a shoot in an unknown city, Duncan lived in Portland and worked along its streets every day, so he captured moments as they unfolded; thus his memories and narration play a crucial role in elevating this book and its images into a work of surprising depth.

Meanwhile, the time and location of Duncan's photography provides a familiar and compelling backstory that, when not front and center, is always bubbling just below the surface. If he had rediscovered forgotten photos of Portland Head Light or the Portland Sailors and Soldiers Monument, it wouldn't be such a cause for celebration. Instead, he teleports the viewer directly onto downtown streets of Portland. The subjects and the city seem to coexist in a time of unease and uncertainty that seeps into each frame. Sure, from our perspective now, we know how the story ends, but that knowledge only adds poignancy and melancholy to Duncan's photographs. No one in them knew what was coming next.

So, it is critical to remember that in Duncan's world, the future remains unknown. The Congress Street retail district is wheezing and barely on life support. Yes, his camera shows us that there are still wonderful department stores and retail shops, but the upper floors are deteriorating, the store fronts are tired, and new investment is lacking. The district is fraying at the edges, chewed away by drugs, pornography, and prostitution. Most ominous are the clouds gathering from the west, where the shiny new Maine Mall (and all that free parking!) has risen at the crossroads of the region's modern Interstate. It is sucking the very life breath from the city's de facto Main Street. At the same time, the bones of the city are under assault from the forces of urban renewal as the powers that be thrash about searching for a way forward: to undo the economic damage inflicted by the ascendant suburbs, sweeping societal shifts, and a transformative economy. Ironically, at this point it is the neglected and derelict waterfront that is slowly rising from the rubble, only intensifying the struggles of the downtown district. At this moment, as Duncan sits at his taxi stand across from Paul's Food Center, he can't know that in less than twenty years, Congress Street will be dead, a depressing collection of empty storefronts and ghosts.

As it is, the streetscapes on which Duncan lives and drives are remarkably different from just a decade earlier. Entire blocks and neighborhoods have been razed and historic streets rerouted or eliminated. The businesses in the historic Golden Triangle off Monument Square have been demolished and forgotten. When Duncan drives past the Triangle area, it is a depressing, chained-off parking lot for 160 cars. Many other homes and buildings throughout the city built tight to narrow, crooked streets are giving way to straighter, wider boulevards and to larger, less personal corporate towers and structures. At least that is the plan.

If we leap even further ahead, to another two decades beyond the death of Congress and the closing of Porteous in the 1990s, we also know that Big Money will roll onto the peninsula bringing shinier buildings, expensive hotels, pricey restaurants, and an Arts District. We know that tourists will flood the streets, some spending upwards of $1,000 a night to stay in a boutique hotel or shelling out a million dollars for a waterfront condo. In Duncan's Portland, young adults are paying maybe $100 a month to live in Spartan apartments off Brackett Street, visiting dive bars like Eddie's, and dancing on the upper floors of essentially empty buildings with jugs of cheap wine and a few smiles. What has been gained and what has been lost is a debate that will rage forever across the city. I suspect Duncan's book will only add fuel to that fire, which is not necessarily a bad thing.

When I step back and look at Duncan's seventies photos and text as a larger narrative, I am reminded of the movie "American Graffiti." George Lucas' coming-of-age classic offers a similarly narrow focus—the last night of summer in 1962 for a group of local teenagers. The next day some will head to college, some to adulthood, and they are uneasily living in that seminal moment just before life changes forever. Since it is the fall of 1962, we know an era in American society and pop culture is ending. In 1963, a new era—far different from the 1950s—was truly taking hold. The Beatles and the Vietnam War were waiting in the wings to take center stage. We know all this as we watch the movie. It adds depth and melancholy to the fun and nostalgia playing out over a backbeat of Wolfman Jack, Buddy Holly, and the Beach Boys.

And so it is here in Duncan's remarkable collection of images, at once loose and laser-focused. They provide a similar look at an uncertain moment in time—a fulcrum moment filled with fun, hope, struggle, and melancholy. When it ends, there is no going back. These images will spur people to create their own personal soundtrack and ignite debates and trigger a flood of memories and nostalgia that go far beyond what we actually see in print. Many of the young adults of the seventies are now in their seventies, typically an age of reflection. They will remember a time when, warts and all, the city of Portland was *their* city—a city that to a young adult seemed a little exotic, a little dangerous, and a whole lot of fun. In short, a city just like the seventies.

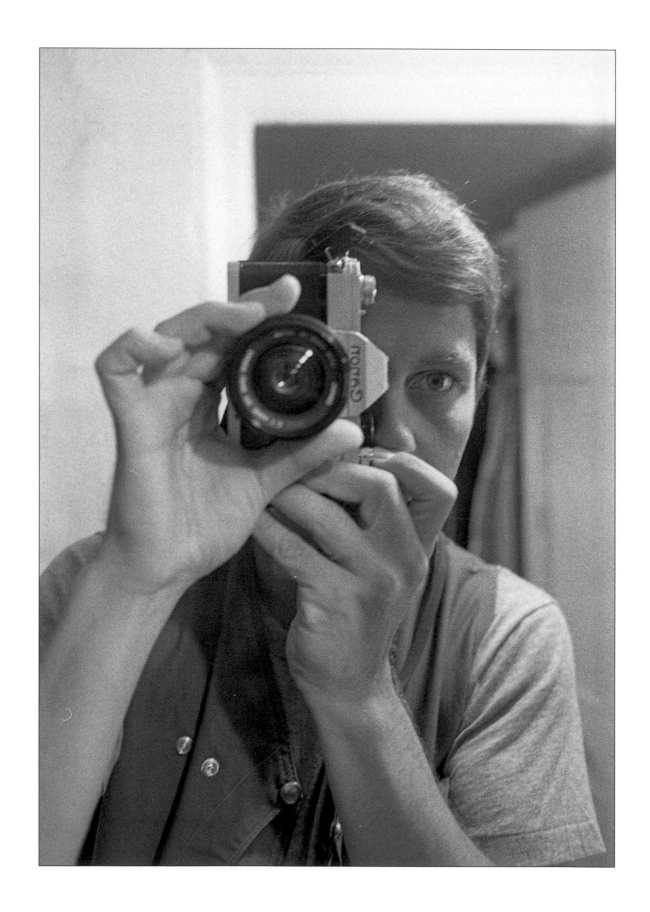

Author's Note

I began taking photographs when I was twelve years old.

I was immediately hooked. And I still am. My wife, Susanne, sometimes complains that I always have a camera with me and that I should just enjoy my surroundings rather than shooting photos. But at this point, this is just who I am. Holding a camera is how I enjoy things.

She can blame my father, also John Duncan, who gave me my first camera. It used Kodak 620 film which was invented in 1931 and discontinued in 1995. When I got that camera, I joined the photo club at my junior high school and began taking pictures, developing film, and making prints the old-school analog way.

The school had converted an old utility closet into a darkroom for the photo club. The first time I opened that closet door, a whole new world lay before me! The shelves were lined with bottles labeled "developer," "stop bath," and "fixer." The enlarger stood on a wooden base, with a steel shaft extending upwards, and the enlarger housing sat on the top with a knob on the side so it could be moved up and down. Once inside the room, in total darkness, I would open the end of a 35mm film canister—hopefully containing great images—using a church key, remove the film, and slowly unwind it onto a stainless-steel reel. Once the negatives dried, it was time to print. Magic happened when I placed the paper into the developing tray while gently agitating the liquid—the image slowly appeared before my eyes. The sense of anticipation was intoxicating. There is no instant gratification with analog photography.

In recent years, despite the ease and convenience of digital photography, I have at times returned to those old labor-intensive processes. I realized that with digital, I missed the anticipation of removing the processed film from the reel, holding it up to the light, and seeing the negative images roll by frame by frame. I missed the experience. I think shooting and developing photos is a sensual process; the eye, the tools, putting film into the camera, measuring light, aperture, speed, focus, pressure, release, then, the audible click. I also loved the work of measuring and mixing chemicals, checking temperatures, timing the developer bath—I even loved that unique chemical scent that filled the air. In a darkroom, one loses his sense of time. It is addictive.

I also wanted to be good at it. In the school library I looked at as many books of photography as I could find. I pored over images taken by the likes of Henri Cartier-Bresson, Margaret Bourke-White, Alfred Stieglitz, Dorothea Lange, Edward Steichen, William Eggleston, Alfred Eisenstaedt, Diane Arbus, Weegee, and David Douglas Duncan to name a few. These image-makers influenced me greatly, even at that young age, and provided me with the foundational concepts that I would instinctively develop and use as my adult life unwound. I would eventually take an exhilarating, joyful, hazy, experimental, and at times exceptionally chaotic and disjointed, personal journey through the seventies—talk about your experiences!—all with a camera in my hands as much as circumstances (and money!) allowed.

I grew up in Falmouth. John, my father, and Florence, my mother, adopted me as an infant and I spent my formative years living on Johnson Road. My mom worked as the principal at Underwood School (now known as Underwood Park

In a darkroom, one loses his sense of time. It was addictive.

A self-portrait in the 1970s using my Canon and a mirror.

because the building is long gone) off Route 88. She was very protective of me, which I did not appreciate as an adolescent boy. She died when I was seventeen of a heart attack before she was fifty. My father, a stern man of Scottish descent, grew up in Howland. He taught school for a couple years, but later moved on to the American Can Company where he worked as a clerk.

Academically, I was an average high-school student. However, one day when I was a junior, the physical education teacher, Frank Littlefield, saw me outrun everyone during a class. He immediately asked me to join the track team. I did and quickly blossomed into quite the track star. During the next two years, I set the state record in the half-mile, broke the record in the mile (but finished second in the race), and set the Cumberland County Conference record in the two mile. I finished second in the cross-country state championship meet. Although I had been bullied since grade school, my athletic success quickly gained me some respect and recognition. I liked it! All in all, I was a pretty straight-laced kid and lived a relatively uneventful childhood in the suburbs of Portland. I graduated from Falmouth High School in 1969—at the dawn of a summer that would change everything, including my life. In some sense, the only thing from my upbringing that survived the summer of 1969 was my love of photography.

When I was eighteen, I bought my first SLR camera at Fotoshop on Congress Street. It was at that moment that I began to photograph my way through life, whenever I had a camera, that is, because, admittedly, I have lost and sold (I usually really needed the money!) my fair share of cameras over the years.

Soon after I bought the camera, I met Lenny and Joe, two freaks really, near the State Theater. Lenny was wearing a leather coat with tassels and Joe was wearing a long black trench coat. When they realized I had a car, a Plymouth Valiant, they immediately asked me if I would drive them to McGill University in Montreal to "score some acid." I was eighteen, a high-school graduate with no responsibilities, and a growing curiosity about life beyond the coast of Maine. And I was an "acid virgin."

I quickly agreed.

In Montreal, Lenny and Joe bought some sheets of acid, we took a hit, and started the drive back to Portland. When we reached Vermont, the border agents didn't like how we looked—longhaired and undeniably looking worse for wear. They searched my car and found a pipe. They proceeded to tear the car apart. So, here I was with two guys I barely knew, rather high, and thinking my life was over—busted for drugs

and jailed just weeks out of high school. I was scared. We were taken to separate rooms and strip-searched. I vividly remember standing naked and staring at a portrait of Richard Nixon. Shockingly, the agents cleared us and sent us on our way. It turns out Lenny had wrapped the sheets around his lower leg, hidden under his cowboy boots, which he never removed. I was not going to jail, after all.

I returned to Portland with even greater curiosity about the world beyond Maine.

In July of 1969, I sat at a bar in Ogunquit watching Neil Armstrong walk on the moon. I was working at a hotel that is now called Seacastles Resort, cleaning rooms and taking care of any other odd jobs that needed doing. For example, the owner, an eccentric older woman, frequently sent me out in the middle of the night to check her raccoon traps.

In August, I left Portland with three friends and drove through the night to Bethel, New York, to attend Woodstock, the now-legendary three-day music festival that attracted upwards of four hundred thousand people. It, as most people know, is often considered the defining event of the counterculture generation. At the time, the four of us didn't know any of that, we just wanted an adventure. In New York, we parked our vehicle a couple of miles from Max Yasgur's dairy farm, where the festival was held, and walked to the gates. We didn't bring anything with us; no food, no camping gear, no extra clothing, nothing. It never crossed our minds!

At the festival, drugs were easily available. On Saturday, I took some of the infamous brown acid. As the acid trip began, I remember stumbling along the grounds in a wooded area and in my tripping imagination I was suddenly caught in a river of people all flowing toward a vortex, like a bathtub drain, where I was going to be sucked into a void from which I couldn't return. In fear and desperation, I started running, as best I could, in the opposite direction of the vortex, struggling against an imaginary current of people while also pushing my way through real people. When I emerged from the woods somewhere near the stage, I could hear Creedence Clearwater Revival playing "Bootleg" and I felt the urgent need to lay down, but as I did, I suddenly felt as if I were laying instead on a bed of long nails that pierced my body. My joints and limbs actually hurt. I stayed on the ground, I think, all night without moving.

The next morning, as the acid wore off, I got up and drove back to Portland so I could work on Monday. The Woodstock experience permanently changed my perspective and my life

trajectory—it became a dramatically less-organized trajectory, as for so many of my generation. I began reading books by the likes of Hermann Hesse, Carlos Castaneda, Ken Kesey, and Jack Kerouac, I questioned the "reality" around me and had an unquenchable thirst for more experiences. I needed to see things.

After Woodstock, I sold my Plymouth Valiant and bought a Honda CB350 motorcycle. I rode that Honda to the Gulf Coast, then turned west toward Texas, where I ran out of money. I was flat broke (it would not be the last time). So, I sold the bike and hitched the rest of the way to Los Angeles. My goal was to reach San Francisco by Christmas and stay with friends. I have no idea what happened to my camera, but I don't have any pictures of that trip.

At some point after leaving California, I found myself in Gillette, Wyoming, working as a roughneck on an oil rig with a fellow Mainer, James "Jim" LeDue, and another friend, Michael Allport. (Jim would later become a pioneer of the foodie revolution in downtown Portland, starting the Good Egg Café, Alberta's, and Bella Cucina restaurants.) I had hitchhiked out from Portland. I stayed at the Lazy U Bunkhouse run by C.T. Landers and his one-legged wife, Maud. They were well-known—you could arrive in town broke and destitute and they would put you in the bunkhouse, give you credit at their diner, and hook you up with a drilling foreman.

The work was not for the faint of heart. It was noisy, muddy, loud, and dangerous. I was picked up each morning at five and driven an hour to a drill rig in the middle of a vast empty prairie. I worked twelve-hour days under the drilling platform shoveling mud away from the casing that contained the drill pipe. I lasted a couple of months.

When the summer of 1970 rolled around, I was back in Portland and took a job working as a deckhand for the Casco Bay Lines. I was paid two bucks an hour and all the Boone's Farm Apple Wine I could drink. Which I did. A lot. As the ferry sailed between the islands in Casco Bay, other crewmates and I would sequester ourselves on the lower deck bow drinking wine and hoping we could still hit the pilings with the ropes when we docked.

In the fall of 1970, I made my way west yet again, this time landing at Hastings College in Nebraska. I fell madly in love for the first time. Dianne was a senior and I was a freshman. It was my first true romance (and all that goes with that). I essentially lived at her apartment instead of the dorm. That spring,

John Duncan, Falmouth High School Class of 1969

she graduated and our romance ended. I returned to Maine brokenhearted. While at Hastings, I majored in psychology and wrote a paper in my Abnormal Psych class that analyzed how my acid trip at Woodstock related to my search for identity. The professor gave me an A++! Let's just say that during my freshman year at Hastings, in addition to love, I was very interested in exploring altered states of consciousness and it showed.

That fall, I was in Portland when I got a letter from Dianne. She said she missed me and wanted me back. I was a hopeless romantic. I quit work, jumped in my VW bus and drove nonstop to Wyoming, where she lived. I knocked on her apartment door and she answered, "What the fuck are you doing here?" Turns out she was drunk when she wrote

After attending Woodstock I let my hair down in more ways than one.

That was what my life, and life for a lot of people, was during the seventies—experimental, transitional, and unplanned; an experience.

the letter and didn't mean any of it. She offered me the couch for the night; then out! We may have had a final fling at some point before morning, I really can't remember. I do know that I suddenly found myself in Cheyenne, Wyoming, still with no girlfriend and once again flat broke.

I rented a cheap apartment and got a job at the Little America Truckstop where I worked pumping gas and washing windows for the big rigs. While working at the truck stop, something else weighed heavily on my mind—Vietnam. I had a low draft number, 125, so I assumed I would be drafted at any moment. I considered two options: hide out in Canada or enlist. I drove to Colorado and joined the U.S. Air Force.

Turns out, that wasn't a great plan either. I completed basic training in San Antonio and was eventually stationed at Griffiss Air Force Base in central New York where I worked on airplanes, B-52 Bombers, to be more precise. I hated it. I tried to get out by telling my superiors that I had done LSD. They didn't seem to care. But soon enough I got in trouble for protesting our military actions. One day I got very mad about something, refused an order, and yelled at my commander. I was trying to flee the base in my VW when I was apprehended by the MPs. They gave me a drug test and sent me to see the base psychiatrist. After a few sessions, he classified me as "Passive Dependent Character Disorder-Unadaptable for Military Service." I received an honorable discharge and was sent home. I was a free man.

Back in Portland, I took a job driving a twelve-hour night shift—four p.m. to four a.m.—for Town Taxi (I also drove for Yellow Taxi at different times).

It was here that I seriously began to work on my skills as a street photographer. By this time, I had upgraded to a Canon FTb. And I had bought a 20mm lens that encompassed an 84-degree-wide field of view. I loved it. That camera produced most of the images you will see in this book.

My primary cabstand was located on Congress Street, near the old Paul's Food Center. I would take pictures while I was driving the cab and I would take pictures while waiting for a fare. Sometimes, I sat in one place and took pictures of whatever happened on a street corner or at a crossing. Sometimes I would just walk and shoot in sort of one constant motion; just stick out the camera and snap something without breaking stride. I also experimented with different styles of photography while hanging out with friends or drinking in the bar. I took thousands of pictures. I loved capturing human behavior in its various manifestations. I photographed who and what was before me, because it was there (and because I was often drunk or stoned). Little did I know that, fifty years later, all these snapshots would become a wonderful record of my past—my visual diary—and, in some ways, a diary of a time, a place, and a way of life.

Driving a cab at night often presented the opportunity for a new adventure or experience. When the bars closed, the all-night B.Y.O.B. clubs opened. These were prominent in Portland during the seventies. On Preble Street there was a place called The Nite Life. In the winter, I took fares from there to the infamous all-night Dunkin' Donuts at Congress Square. A virtual potpourri of humans moved through that place in the wee hours—hippies, hookers, and night owls, all having coffee, dealing drugs, hanging out, or just passing through.

Typically, cab drivers kept forty percent of every fare and gave sixty percent to the cab company. But sometimes, when driving a short fare for a regular customer, drivers would turn off the meter and just pocket the whole fare. On Sundays, back when alcohol sales were still forbidden, smart drivers carried some beer and spirits in the trunk to sell to people who requested it. The extra cash helped.

One night, I picked up a young woman at the Greyhound station with her two young children. She was my age and newly divorced. She arrived with no place to stay, so I offered my place for the night and then got her a hotel room in Old Orchard Beach. Like many young people at the time, she wanted to move west to San Francisco and live in Haight-Ashbury. She had some money from a recent divorce settlement and didn't want to travel alone. She offered to pay my airfare if I would help her find an apartment in San Francisco and then help her buy some bicycles to start a rental business at the entrance to Golden Gate Park.

I immediately agreed.

Once we reached the Pacific, we found a room at the corner of Haight and Clayton streets, just three blocks from the park entrance. But after a month of frustration (and a failed bike rental business), I returned to Portland and my taxi with another story to tell. That was what my life, and life for a lot of people, was during the seventies—experimental, transitional, and unplanned; an experience.

During another stretch away from Maine, I lived in Portland, Oregon, where I got a job at the Delphian School. I worked on the farm milking a dozen cows and working the

fields while at the same time learning the Scientology rituals required of all staff. It was all very strange. Soon, I ran the school's kitchen and cooked for three hundred staff and students. I was paid next to nothing, but did receive free room and board. Then one day the school gave me $350 cash to go buy supplies in nearby Portland. Instead, I left campus and never returned. I used the cash to buy a Greyhound ticket to Florida. Another experience.

Through it all, no matter how often I left, I always came home.

Like myself, Portland in the seventies was in transition. The Maine Mall opened in the early seventies and slowly, but surely, it and other changes sucked the life out of the downtown business district. In fairly short order, Woolworth's, W.T. Grant's, Porteous, and Benoit's all disappeared, and the list goes on. Congress Street by the nineties would feature a string of empty storefronts.

Franklin Street officially became the four-lane Franklin Arterial after more than a hundred buildings were razed. But roughly during that same era, Portland's Old Port, parts of which had sat derelict and dangerous for years, began moving in the opposite direction. The city began to put a focus on preservation versus urban renewal. The Old Port would slowly emerge as the city's focal point for tourists, arts, and culture. And lots of bars! The Old Port Tavern was a pioneer in the district. As this happened, the so-called remaining working waterfront suffered and many of the traditional ways of life for a seaport disappeared. I once tried to work at a fish processing plant on the wharf where J's Oyster is now located. I only lasted a few days. The smell and stench were brutal. I also remember a foundry in the area where the noise from the constant pounding of large tools echoed throughout the East End.

While some stores closed, new styles of stores began to replace them. Food co-ops began to appear during the seventies. The Good Day Market opened in 1970 at the Mariner's Church Building, and later moved to Fore Street. In 1979, it established itself on Brackett Street, after the building, the former Brackett School, had been repurposed. The large "Services & Items 4 Sale" bulletin board at the market's entrance was a prominent part of the store's role as a community resource. The Hollow Reed opened on Fore Street in February 1974, owned by Victoria Jahn, Bobbi Goodman, and Frank LaTorre. It was a beloved vegetarian restaurant. Sam Hayward, chef and owner of Fore Street restaurant, says that The Hollow Reed was one of four restaurants from the Old Port's early days that deserves credit for the city's current reputation as a foodie destination.

I loved so many of those old places—so friendly and inviting.

As the decade drew to a close in 1979, I left Portland for Europe. I left on the day of the Three Mile Island disaster with two hundred dollars in my pocket and a one-way ticket to London. I spent time in Scotland working on a barge in the North Sea, in Italy picking apples, and visited many other places in Europe such as Spain, Greece, Yugoslavia, and Turkey. I took many temporary jobs, before meeting my life partner, my second wife, Susanne, and she took me to her homeland of Sweden. (I married my first wife, Patricia, while living in Portland during the seventies.) I did not return to the United States until 1987 with Susanne, and Joel and Leo, our three- and one-year-old boys respectively, in tow. In many ways, I was a different man. Fittingly, in some strange circuitous way, our first apartment was on Falmouth Street (who says you can't go home again?).

Portland was also changed. Many of the stores and restaurants I remembered were closed or would soon close. The mix of businesses was changing as taller, larger buildings were going up to house larger companies. It was becoming more corporate. During the nineties, Susanne and I bought a house through Maine State Housing for $75,000. In 2007, just before the crash, we sold it, never having invested much in upgrading it, for $205,000. That, in a small anecdote, says a lot about where Portland was headed. Today, gentrification is a major issue, as in many cities, and the cost of living makes it harder and harder for people to live in Portland due to the high rents and the wild growth of the peninsula.

While I am nostalgic and greatly miss my Portland of the seventies (especially the people; we had so much fun!), I have also watched what I consider welcome changes. When the Vietnam War ended, Portland's demographic slowly began to shift. Over the ensuing decades, refugees from Vietnam, Africa, and other struggling areas brought new diversity and an international flavor to our beloved port city, only enriching what, since its founding, had been a mostly white, Anglo culture. Thankfully, that is continuing to happen. Portland is more diverse, especially the peninsula.

The Old Port has emerged as a true destination for tourists and new life has been breathed into Congress Street. Maine College of Art is now in the landmark Porteous building, creating what is called The Portland Arts District. Congress Street

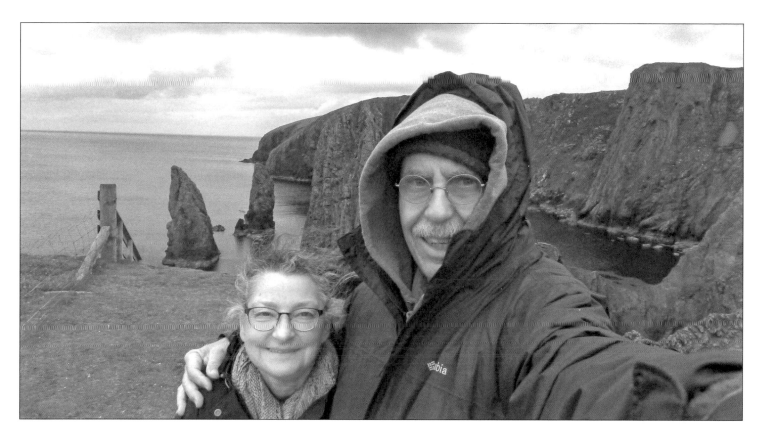

My wife, Susanne, and I visited the Shetland Islands in Scotland in 2019.

hosts a collection of galleries and eateries and events. I love seeing the new vibrancy within our city. I still get out almost every day, still thrilled to capture new faces and places.

But I also love my images of the past. Decades after I took so many photos during the seventies, and despite multiple moves and sometimes chaos, I rediscovered those old images, most never printed and many I can't remember shooting. As I digitized the negatives, I not only began to relive and remember the seventies and the people and the places, but I began to share them. The response was terrific. Metaphorically speaking, photographs are like wine, becoming imbued with subtle changes over time.

As with fingerprints, no two are alike. Moments frozen the split second the shutter is released stay true. Now becomes then. The connections between the present and the past astound me. In my photos, people, now so much older, see themselves on the streets as young kids. It brings them such joy! Their joy is my joy. Stories continue to emerge, knitting together various strands of a mutually shared physical space.

Our personal history, with the publication of this book, is now part of Portland's history.

Whenever I look at a century-old image of a family in a studio, posing stiffly looking directly at the lens, I always ruminate about who they were, where they were, what was their joy, what was their pain? People, like cities, are always evolving and changing—often at high speed. A photograph stops time for a second and allows us a chance to reflect. Portland will always be my home. I love it. And I feel grateful to have worked as one of its unofficial biographers for all these years, whether I knew it or not. And I am indebted to all the people who have lived with me, loved me, partied with me, and allowed me to take their pictures.

It has been an amazing ride—a true *experience*.

—John Duncan
August 2021

Take It Easy
PORTLAND IN THE 1970s

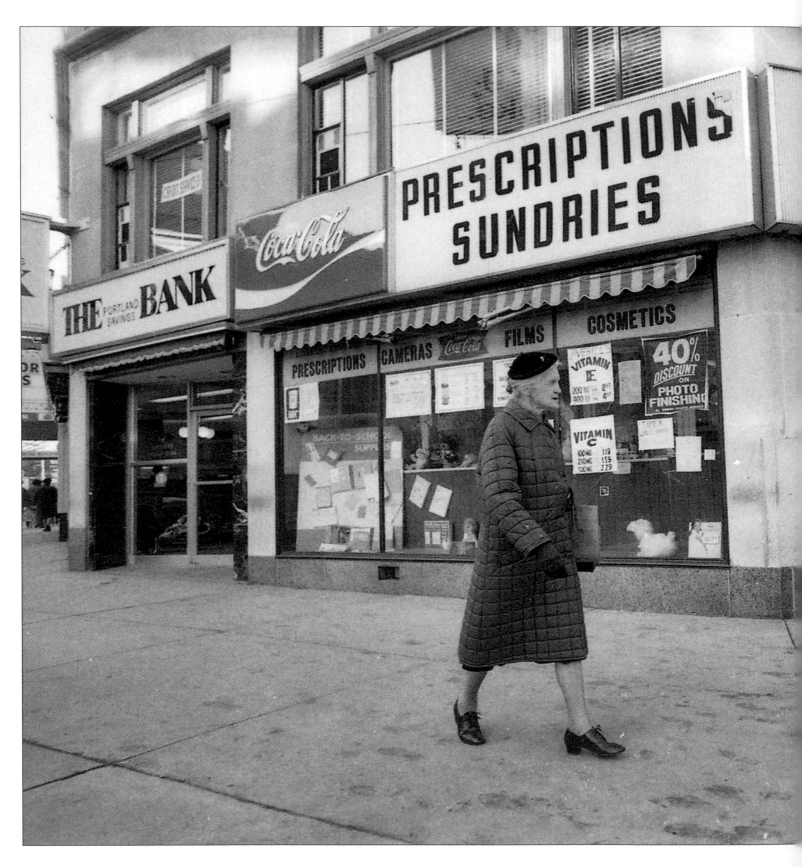

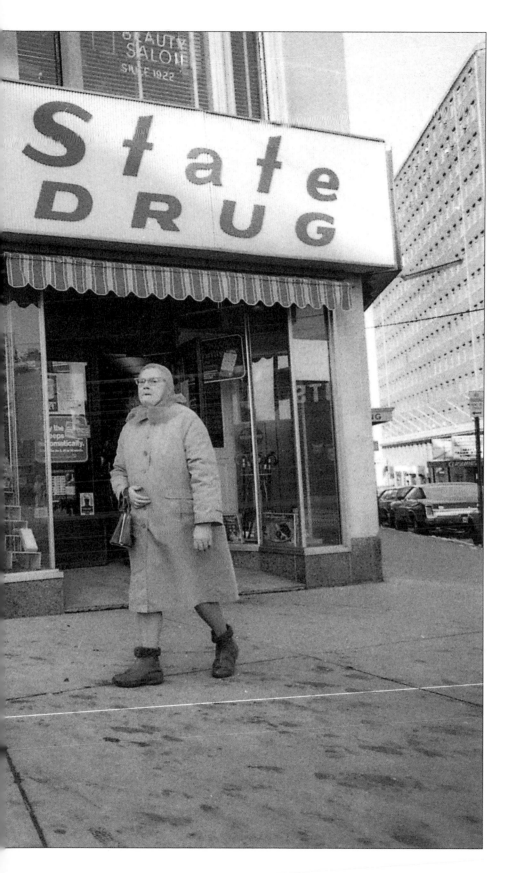

One of my favorite photos. Two elderly women crossing in front of State Drug located in the State Theater building at the corner of High and Congress streets. You can see an old Portland Savings Bank branch in the background. State Drug opened in 1929 and closed in 1984 after fifty-five years in business.

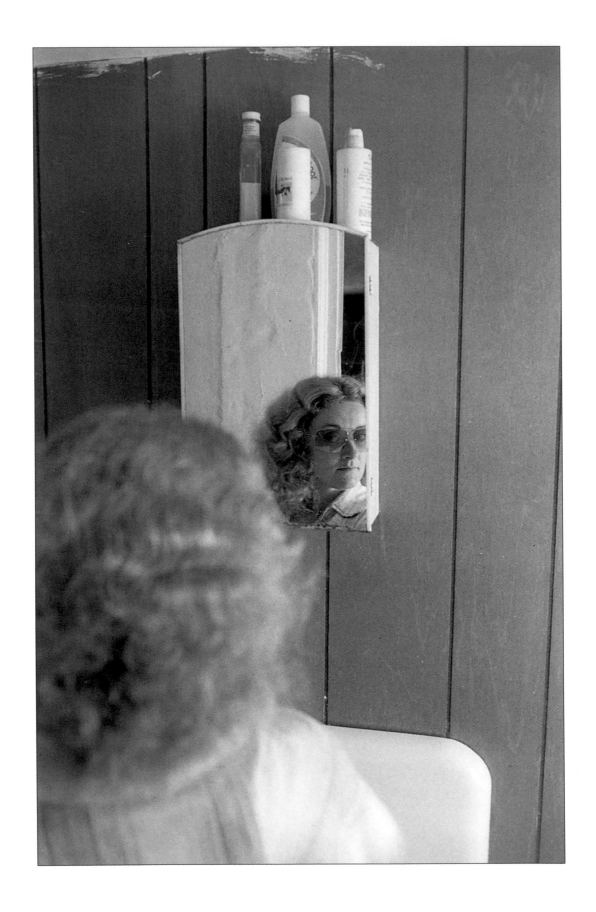

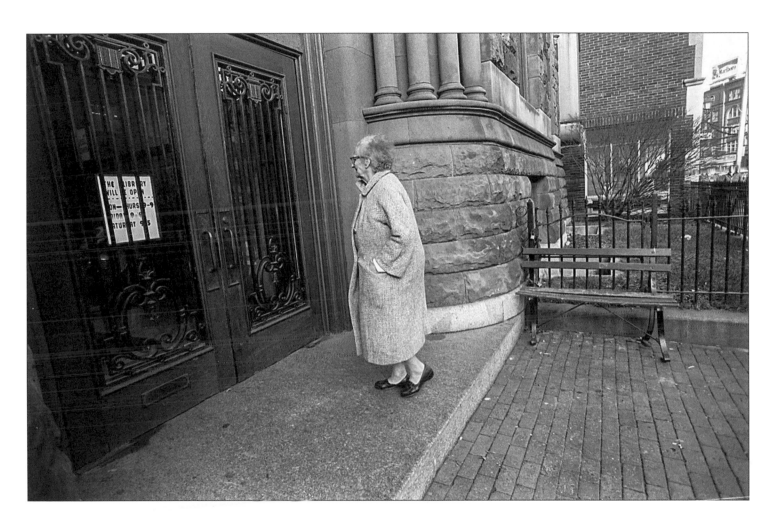

ABOVE: An elderly woman checking hours at the old Portland Public Library in the Baxter Building at 619 Congress Street. The library opened in Baxter in 1889, replacing an older library that was located on Plum Street. The brownstone structure was renovated by John Calvin Stevens in 1928-1929. It remained at that location until it relocated to 5 Monument Square in 1979.
OPPOSITE: My first wife, Patricia "Pat" Strout, in an apartment on Brackett Street. I first met her on a stoop at the corner of Winter and Pine streets, near where my friend Roger lived. We got married at my friends Chris and Kimberly's apartment on Brackett Street and we lived in an apartment in a three-story brick building at Danforth and High.

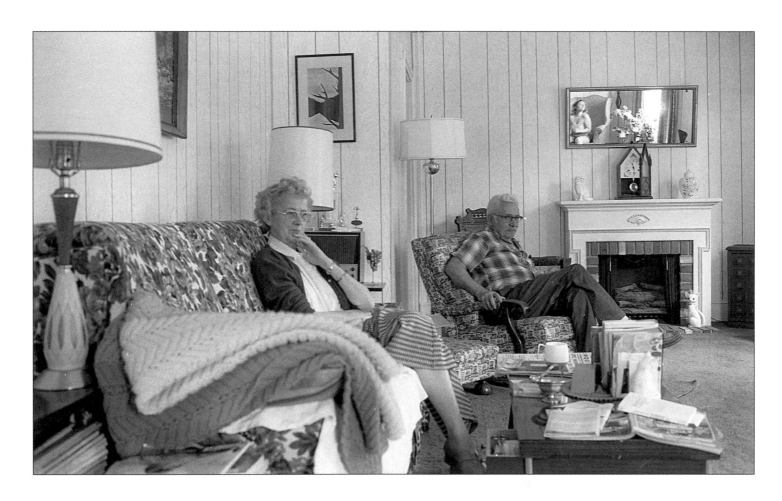

ABOVE: This is Murray Strout, my former father-in-law, with his wife, Thelma. They lived on Meeting House Hill in South Portland. He had a knife-sharpening business with a sign outside that looked like a saw blade. You can see my first wife, Patricia Strout, in the mirror over the fireplace. OPPOSITE: Cheryl Bryant laying in the sun on Casco Bay. Years later, Cheryl ran a day care at the Swedenborgian Church on Stevens Avenue that my sons, Joel and Leo, attended. She now lives in New Jersey.

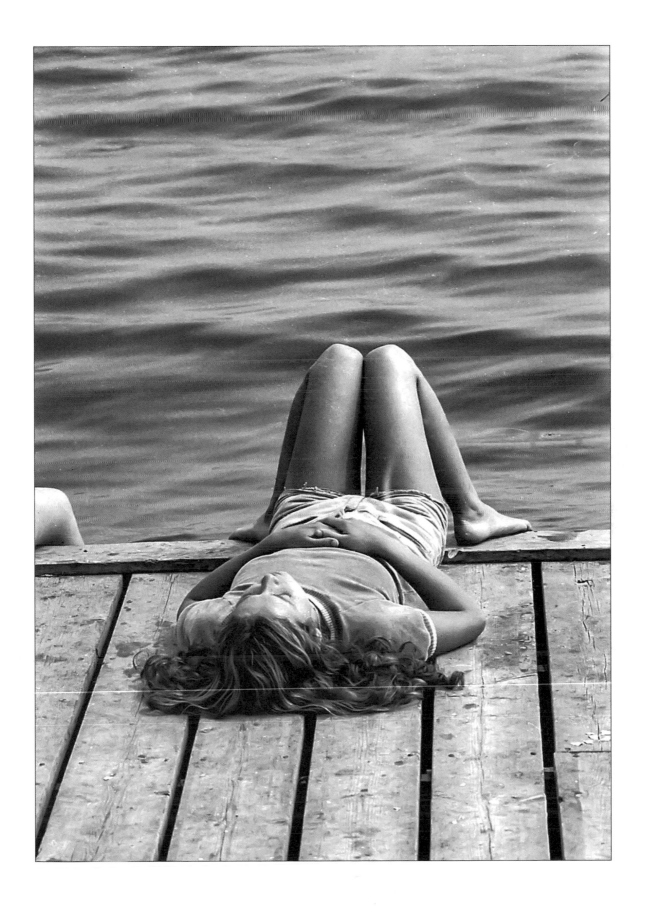

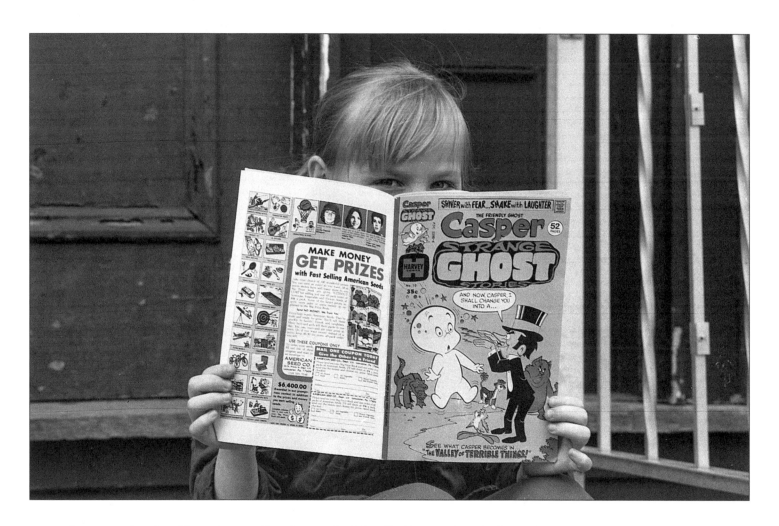

ABOVE: I am guessing the girl was just reading *Casper the Friendly Ghost* and peeked over the top to look at me. OPPOSITE: "Morris" crossing Free Street near The Bag, a restaurant and bar at 116 Free Street. Morris was an iconic and well-known figure at the time. He always wore a trench coat, walked with a cane, and carried a cup asking for spare change. You can see some of the advertising billboards that were installed on some downtown buildings in the seventies. Such billboards were banned in 1978, which dramatically changed the skyline.

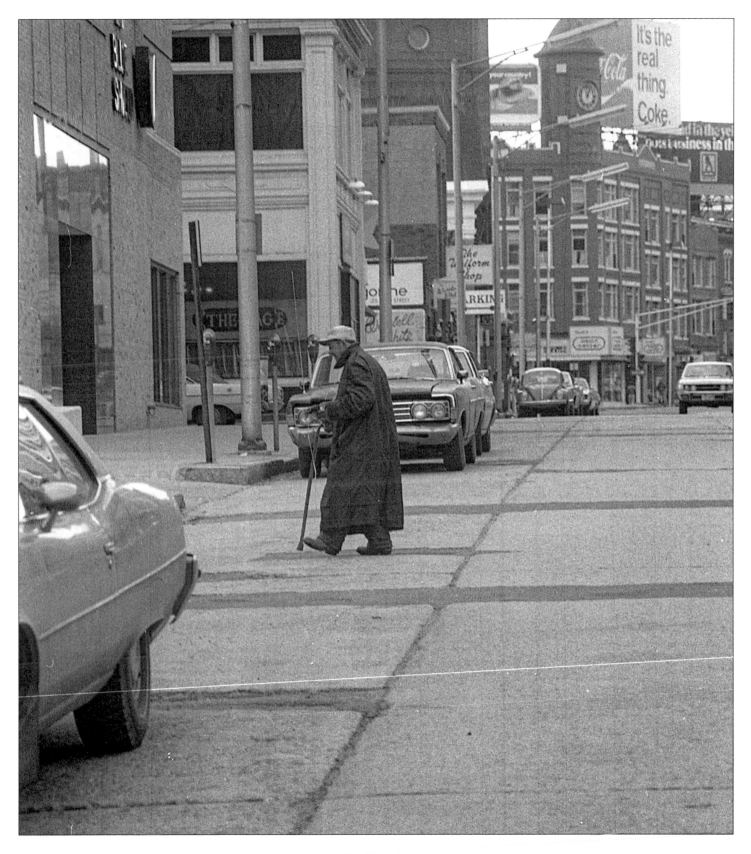

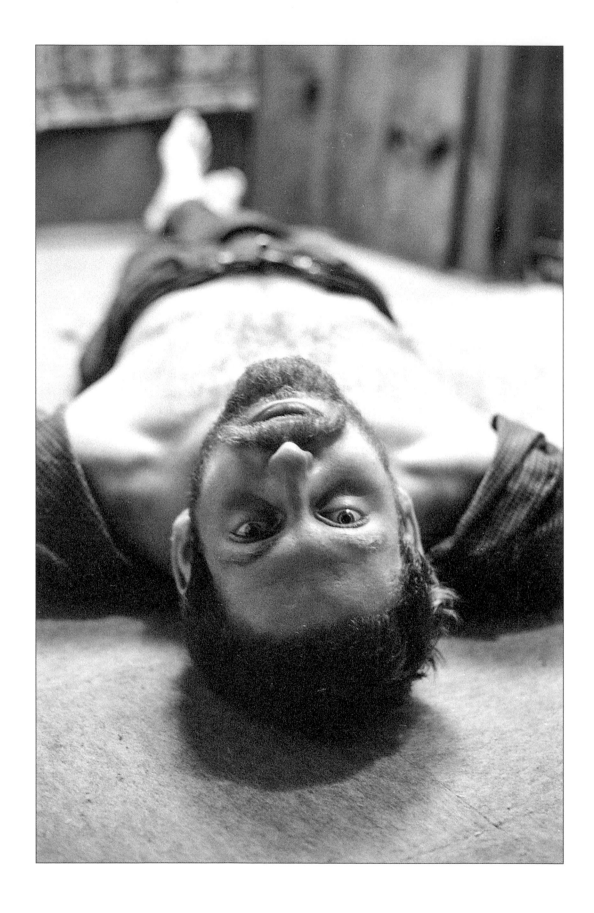

Family

I knew very early on that I was adopted. My mother, Florence, was always worried about how that made me feel, so she constantly impressed upon me the fact that I was chosen. Regrettably, once, in anger, I shouted, "Why did you have to choose me!" She died of a heart attack before she was fifty. I was just seventeen. She had an amazing soprano voice and would practice "Ave Maria" while working in the kitchen. It was beautiful.

Unfortunately, my adopted father, John, and I never truly bonded as father and son. Even after my mother died, we stayed in touch, but remained distant.

I grew up in Falmouth as an only child and always wondered if I had any brothers and sisters. In the early seventies I went to the county courthouse to search adoption records. I thumbed through a drawer of index cards until I found my name and the names of my biological mother and father—Guerino Falconeiri and Geraldine Bowler (her maiden name was Maines). She had divorced and remarried more than once, so I paged through city directories trying to follow her name changes over the years. After a couple of hours, I found her current name, Birosh, and called her.

When she answered I said "Hi, my name is John Duncan and you're supposed to be my mother."

"Oh my!" she answered. "I wondered when you would call."

She lived just two blocks away on Hampshire Street. She told me to come on over. She was a large woman and she greeted me wearing a plain-colored muumuu and woolly slippers. She walked as best as she could across the floor to sit at the Formica table in the kitchen. She sounded apologetic when she told me, "I was a virgin until I was twenty-four, but then I made up for lost time!"

She was often in poor health and always kept a bottle of Cribari, a cheap italian wine, in the pantry to self-medicate. I visited her occasionally and once when I was sitting with a girlfriend, she looked at the two of us and said, "I can tell you guys just want to go home and get some!" I liked her because she was who she was.

My birth father, Guerino Falconeiri, grew up in Massachusetts with seven siblings. His parents were first generation Italian immigrants. He quit school in the seventh grade and eventually moved to Maine to work as a welder at a foundry in Portland. Eventually, I found him too. We finally met in the early nineties at a rooming house across from Portland High School. I have a picture.

My birth parents had three children together—Richard, Martha, and me. Martha and I were given up for adoption, while Richard lived with our mother. I also have six half-siblings. One of my maternal half-siblings, Sharon, worked at DiPietro's Market when I was younger. I would buy Italian sandwiches there and always had an unexplainable feeling when I saw Sharon. Only later did I learn we were brother and sister. I also have a relationship with my paternal half-sister Virginia. Interestingly, her daughter, Janet, once set the girl's state record in the one-mile! It was fun to know running was a family trait.

Geraldine died of cirrhosis of the liver a few years after I met her. The last time I saw her was in the hospital. Her skin was yellow and she was barely conscious. I was driving my cab that night, so I just popped in. I kissed her on the forehead and whispered to myself, "It's time to drop that body and move on." She passed away a few hours later. Her suffering was over.

Opposite: A self-portrait taken in June McCartney's apartment on Williams Street. By this time, I had cut my hair again.

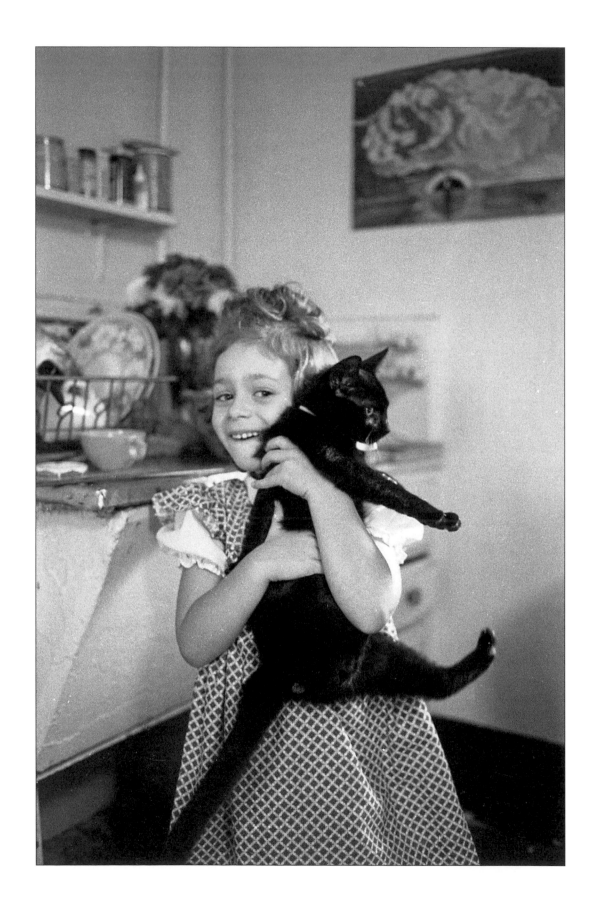

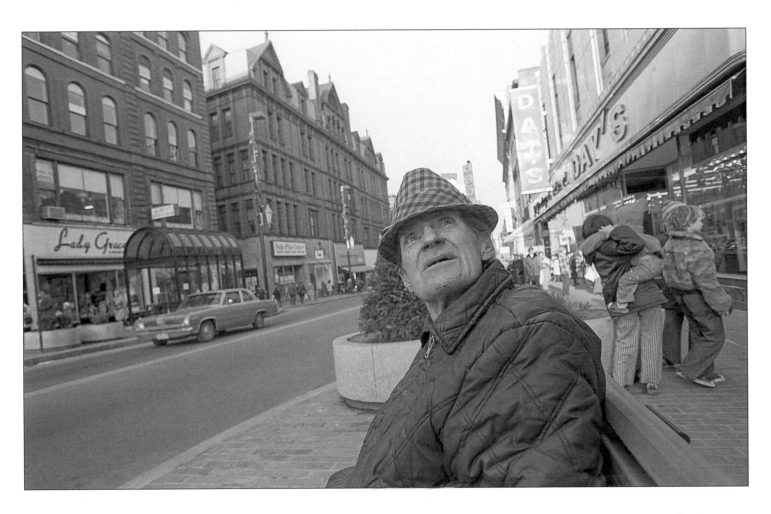

ABOVE: This man in his plaid hat was sitting on a bench outside of Day's Jewelry Store on Congress Street during the Christmas season. Captain Harry Davidson opened the first Day's store on Congress Street in 1914 after ill health forced him to retire from the sea. OPPOSITE: Gabriel Strout and a black cat. Gabriel was the daughter of my sister-in-law, Cathy Strout. This picture was taken in Chris Porter's apartment on the day Pat Strout and I got married.

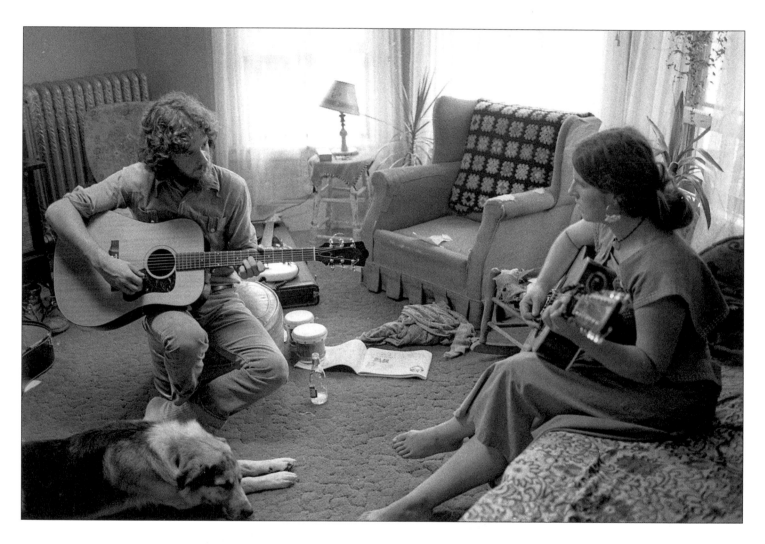

ABOVE: Dana O'Donnell and Beth Blood playing music at their apartment on Tremont Street. Beth started as a folk musician, but moved to a punk sound in the 1980s. She played in several bands, including Ghostwalks and The Stains, which featured George Ripley on guitar, Dave Buxton on vocals, and Joe Potter on drums. Beth also played bass with Bebe Buell in Bebe and The B-sides, a band that included George Gordon, Don Crosby, and Michael Sean McInnis. Bebe Buell is the mother of Liv Tyler, whom she had with Steven Tyler of the band Aerosmith. OPPOSITE: I didn't know these people at the time, but I later learned this is Lee Goldberg's great-grandmother, Gertrude, his grandmother, Esther, and his sister, Stacey, walking along Congress Street. Lee is a longtime reporter and anchor who has retired from WCSH television in Portland.

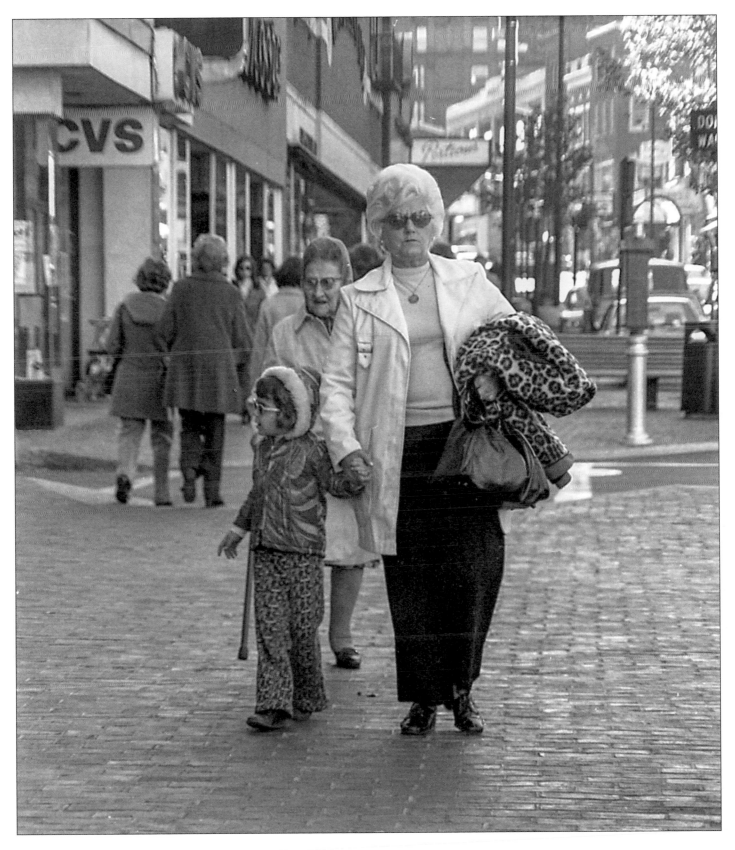

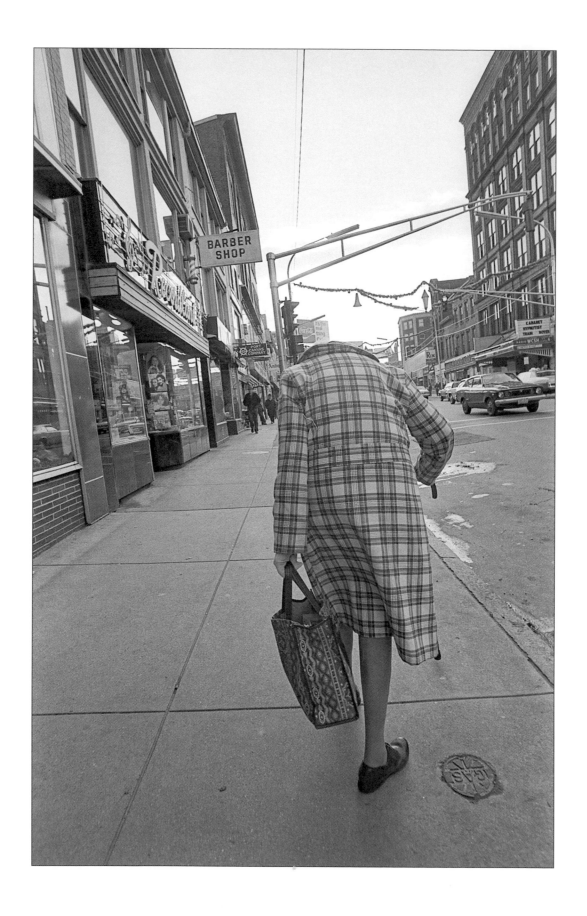

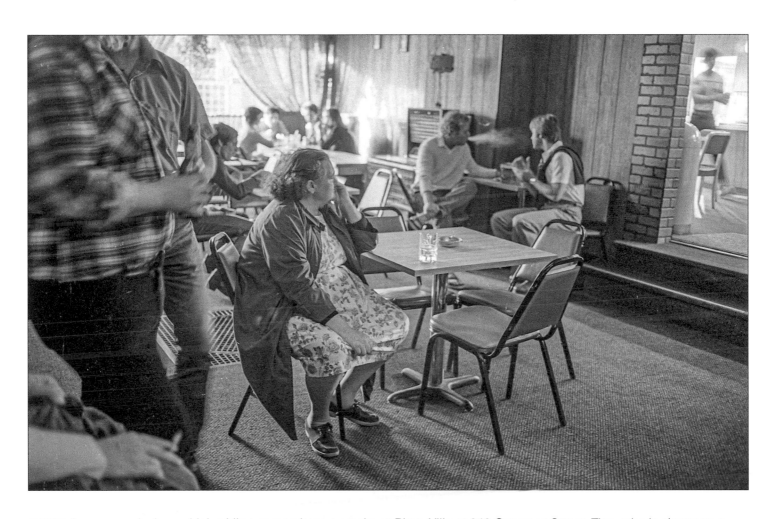

ABOVE: A woman enjoying a drink while two men have a smoke at Pizza Villa at 940 Congress Street. Tina, who is shown as a child on page 48, still works at the "Villa." I love Pizza Villa and ate there many times. OPPOSITE: An elderly lady shuffles past Recordland, near the old WCSH building and the State Theater, at 574 Congress Street. Recordland was a great place for records and music. It was owned by Ruth "Ruthie" Baker, a beloved legend in Portland's music scene. The store closed in 1991 after nearly forty years in business.

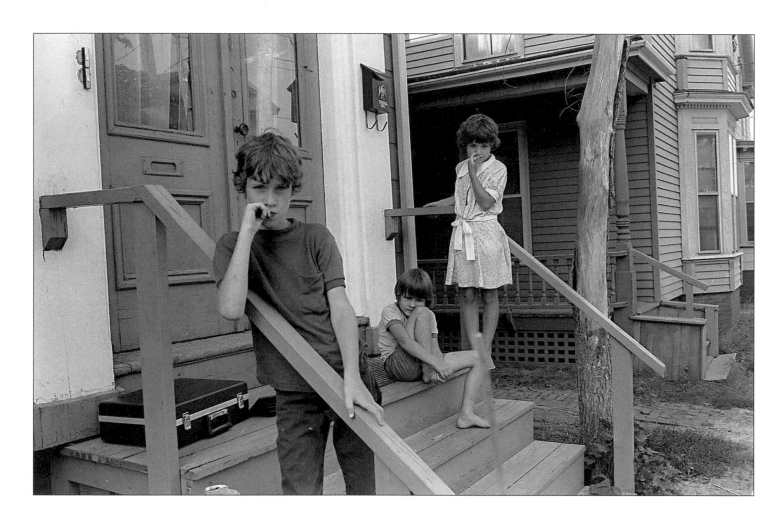

This is Paul Graffam, John Warden, and Michelle MacCormack Smith (also seen opposite) in the West End. I found out Michelle's name earlier this year via social media. It has been so cool making such connections decades after I actually took the pictures. At the time, I often didn't know the names of the people I was shooting.

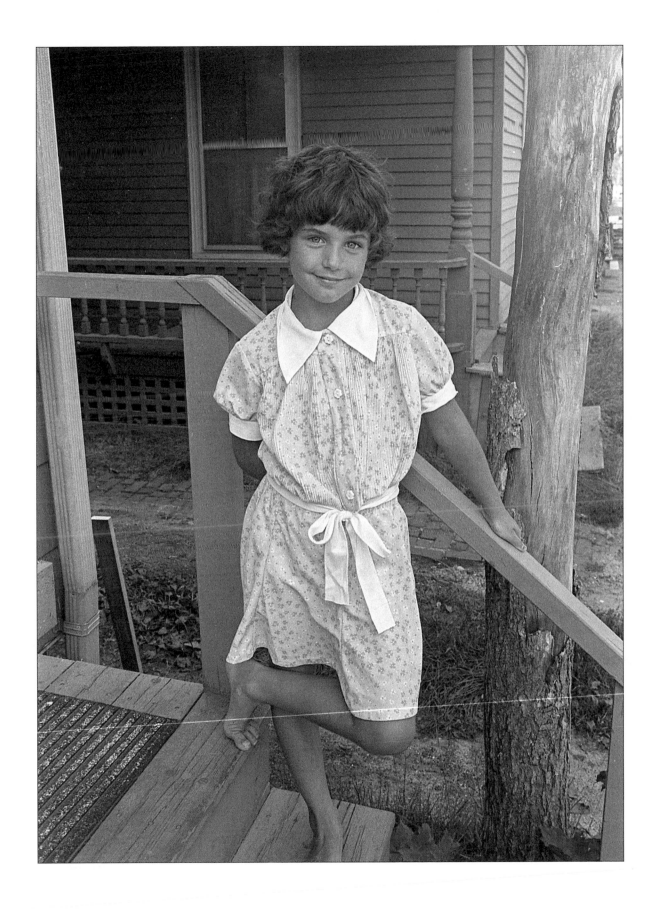

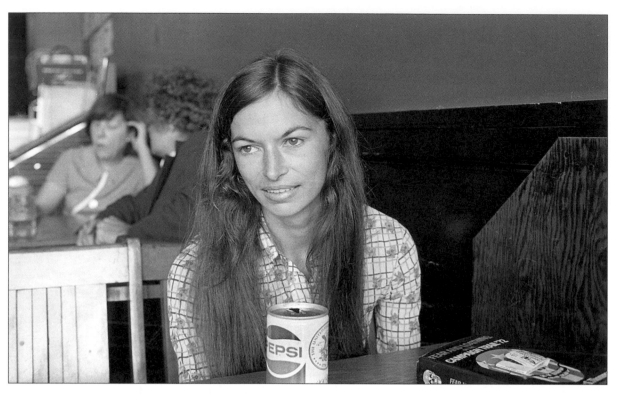

ABOVE: This is Helen, a lovely person. She was dating Quentin "Chip" Sabin, Roger Sabin's brother, at the time. Chip later drowned in Casco Bay. She is reading *Fear and Loathing on the Campaign Trail* by Hunter S. Thompson.

RIGHT: June McCartney

FAR RIGHT: Sandy and a friend at Club Nite Life on Preble Street. In those days, when the bars closed, the all-night B.Y.O.B. clubs opened. I often took fares from here to the infamous all-night Dunkin' Donuts at Congress Square, which saw a virtual potpourri of humans during the wee hours.

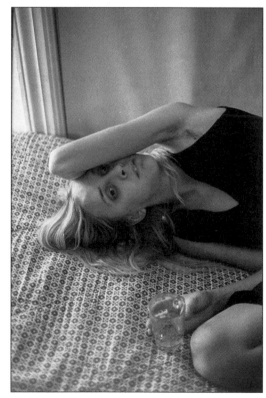

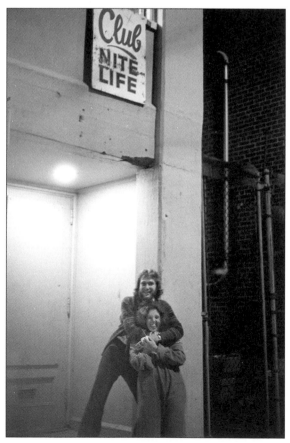

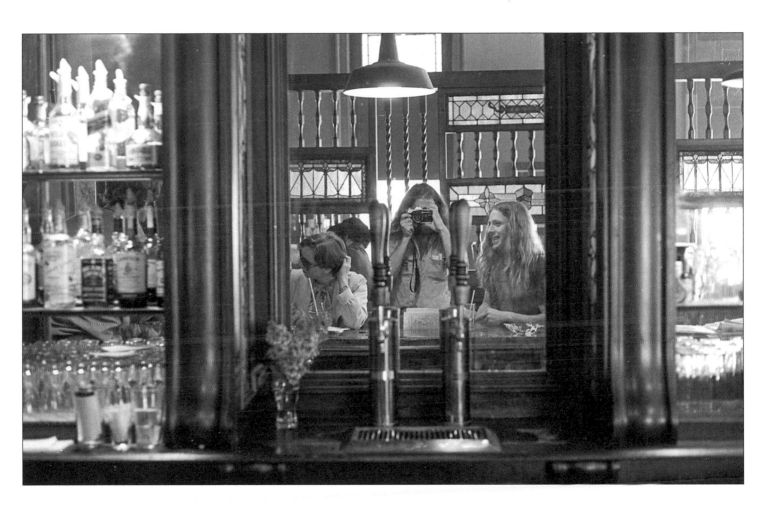

One of my "reflection photos." For a period of time, I took a lot of photos using mirrors. This is at The Bag, a restaurant and bar on Free Street. The Bag was a very popular drinking spot during the seventies and also featured some good music. That is me with the camera.

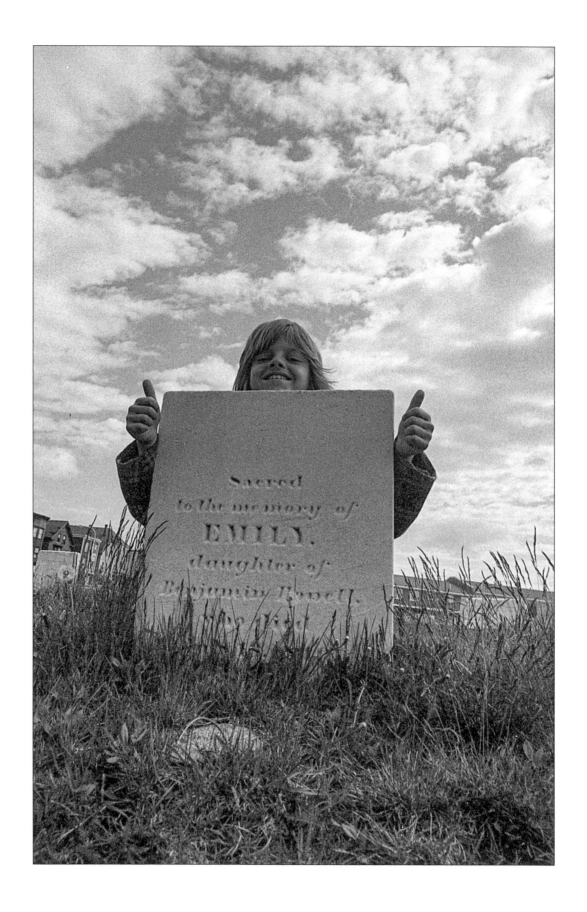

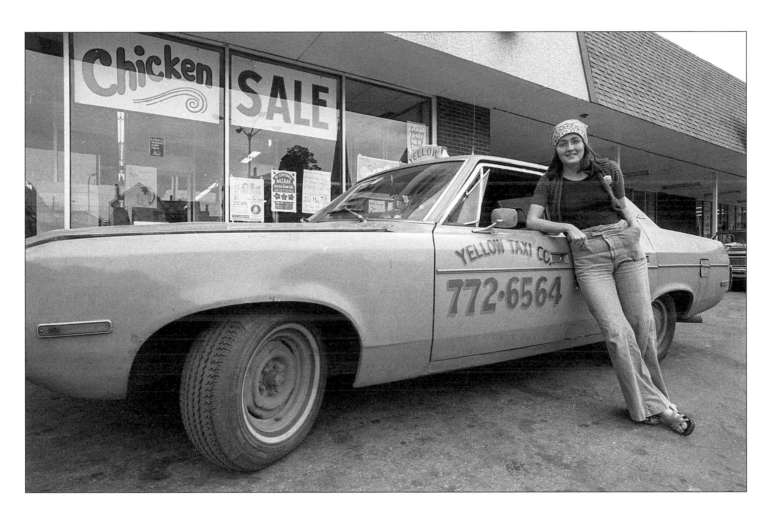

ABOVE: Nadine Byram, a fellow driver for Yellow Taxi, outside a plaza on Forest Avenue. OPPOSITE: I shot this picture in Eastern Cemetery on Munjoy Hill. The cemetery was established in 1668 and is the city's oldest historic site. On some days I would start in the East End, get an Italian sandwich, a quart of Miller High Life, and spend the day walking around the city taking pictures.

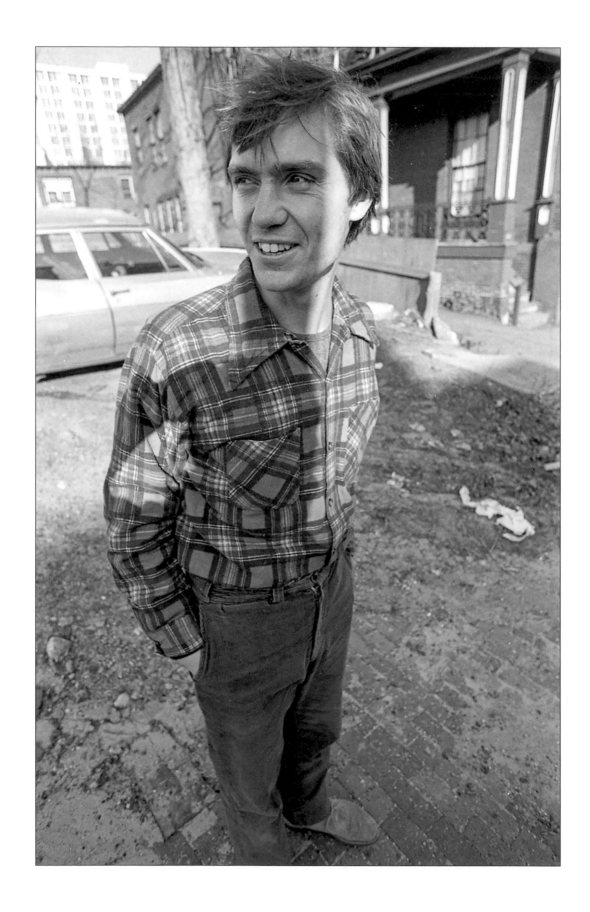

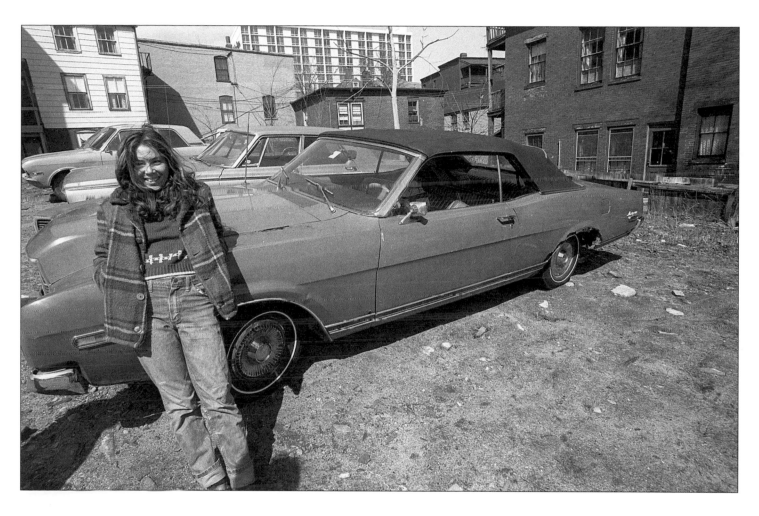

ABOVE: Cheryl Bryant on the corner of High and Danforth streets. Pat and I lived in the building to the right. OPPOSITE: It always seemed to me that Reggie Osborne had a certain 1970s easiness about him. An eclectic guy, he worked at Good Day Market and helped start its offshoot, The Hungry Hunza. He also called contradances for the Back Bay Banana Band, worked as a disco DJ, started a kite festival, danced for Ram Island Dance Company, and performed for Children's Theater of Maine. Not to mention a bunch of other things!

Marlene Chapman and John Read in Marlene's Volkswagen. I went to high school in Falmouth with John, who lived in a small house on Blackstrap Road. All four kids slept in one room. One year, John and I were hitchhiking to Florida and when we reached an intersection we couldn't agree which way to go. Neither one of us would give in to the other, so we just changed our plans and walked off in different directions.

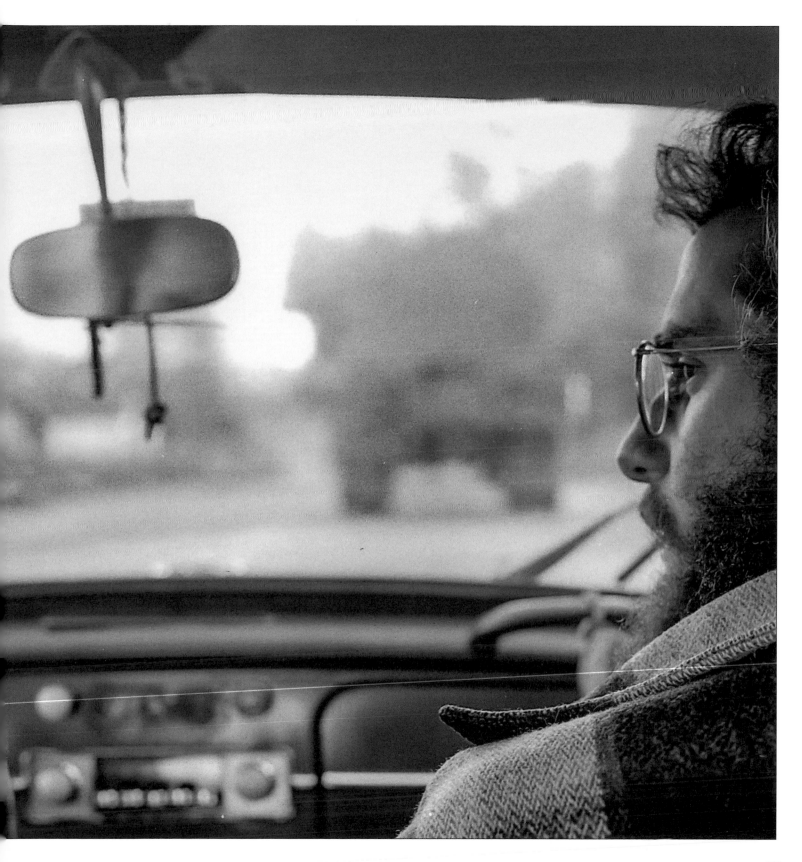

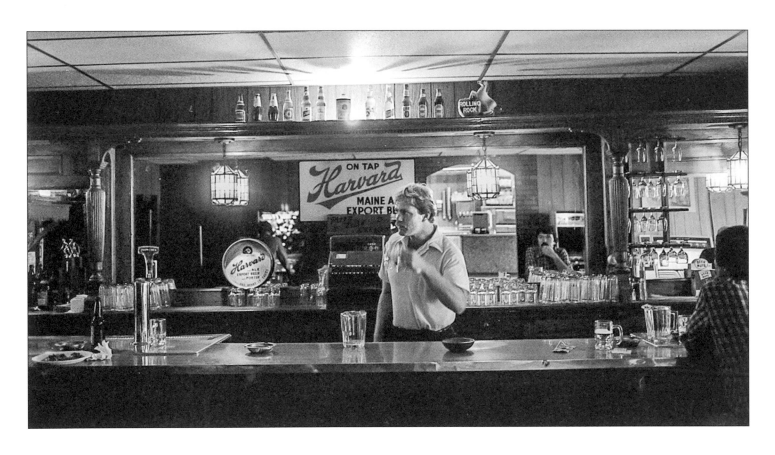

Bob Nutter tending bar at Pizza Villa. I spent a lot of time at Pizza Villa, often with Roger Sabin, who worked as a bartender there for twenty-five years.

Places

Portland in the seventies offered many places to hang out, get a meal, have a drink, or dance the night away. I was a regular at some, while others I knew because I was called to them often to pick up fares. There were also many different vibes.

Some were pleasant. The Gate, a coffeehouse on Congress Street across from the State Theater, was a spot where poets, musicians, and artists would meet to read poetry, drink coffee, and listen to music while also discussing the events of the day. The Grand Orange at the corner of Exchange and Middle streets was a hip boutique with cool seventies things.

Some were cheap. Thankfully. We didn't have much money. Cathay Garden on Congress was a go-to place for an affordable meal, offering a lunch special for just $1.65! And I remember going with friends to a dance party in the People's Building on Brackett Street, a gallon jug of cheap Gallo Red attached to my finger, and dancing up a storm while passing the jug amongst friends.

Some heralded a new era. The Hollow Reed, a beloved vegetarian restaurant, opened on Fore Street in 1974. Some say it is one of the early Old Port restaurants that deserves credit for the city's current reputation as a foodie destination. The Old Port Tavern on Moulton Street opened in 1972 at the historic Mariner's Church Building. At the time, the Old Port was still largely derelict and dangerous, but Old Port Tavern helped signal the beginning of the district's revival. The Seamen's Chapel, on the third floor of the same building, had no electricity and giant cable spools for tables, but people went there to party and dance. If someone played music, they ran an electric cord up from the first floor.

Some were personal favorites—I spent hours at Pizza Villa where my best friend Roger Sabin worked as a bartender. The Bag and Jim's Bar and Grill on Middle Street were a few more.

The small stage at Jim's was pushed up against the front window and, as you walked by, you could see who was performing from behind, as well as the faces of the people who were inside watching the singer.

Some were rowdy. Joe and Nino's on Middle Street and Eddie's Shamrock Cafe at the corner of India and Commercial could both get rough. When I was in the Air Force in central New York, I was a hippie out of water. On many weekends, I hopped in my VW bus and drove back to Portland to hang with old mates at Eddie's, which offered 25-cent beers, a shuffleboard-like bowling machine, and an entertaining patron named "Strawberry." Strawberry would slowly move and dance around the floor, flowing through the room with cigarettes between all his fingers, taking puffs off them in sequence to the jukebox tunes.

Some places could be sketchy. In the seventies, High Street lived up to its name. The address numbers 210 and 212 were well-known as places to buy drugs and mind-altering substances. Some users were mellow, but others struggled. I remember "Lucky" was a fan of methamphetamine, sold mostly by boxers, street fighters, and hard-core users. Lucky lived a life of "need and needles." I would see him all methed-up, talking a mile a minute, gritting his teeth, and hallucinating. He might not sleep for two or three days while just wandering the streets.

And some were fascinating. When the bars closed, the all-night B.Y.O.B. clubs opened, like The Maxx and The Nite Life, which was on lower Preble Street. I often took fares from The Nite Life to the all-night Dunkin' Donuts at Congress Square. At the infamous coffee shop you would see a virtual potpourri of humans in the wee hours—hippies, hookers, and night-owls—all drinking coffee, dealing drugs, or just passing through.

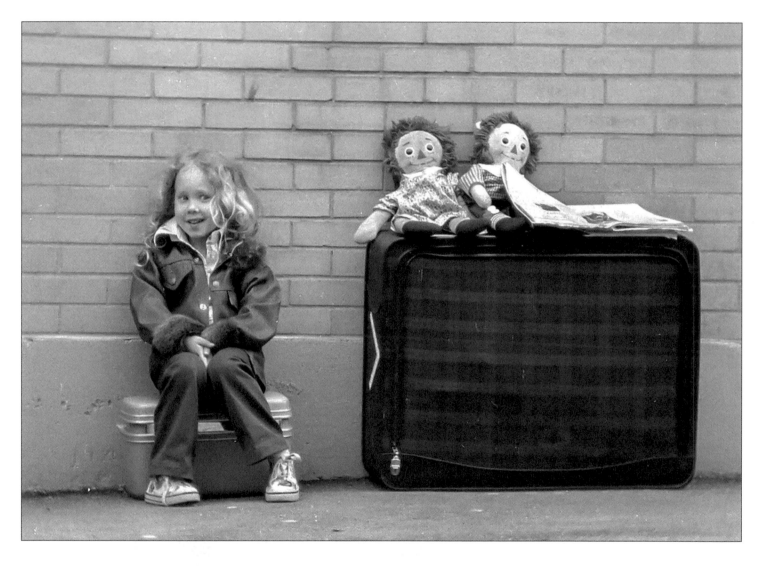

A young girl, traveling with two Raggedy Ann dolls, is sitting outside the old Greyhound Bus Station on the corner of Spring and High streets. The bus stop was a frequent spot for me when I was driving a cab.

ABOVE: Some kids having fun around the holidays with a Salvation Army bell ringer. ABOVE, RIGHT: A boy and girl playing at a water fountain at Deering Oaks. Deering Oaks was another of my favorite places to just hang out. RIGHT: I am sure I just took this photo while I was walking along Congress Street and didn't even stop while I shot it. The girls are walking past The Splendid Restaurant, near Geno's and the Lafayette Hotel. I washed dishes at the Splendid.

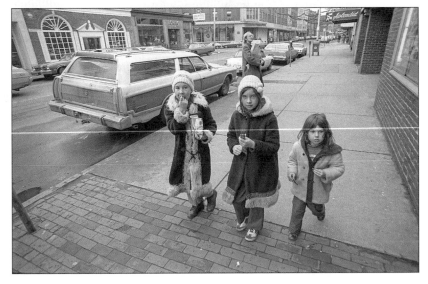

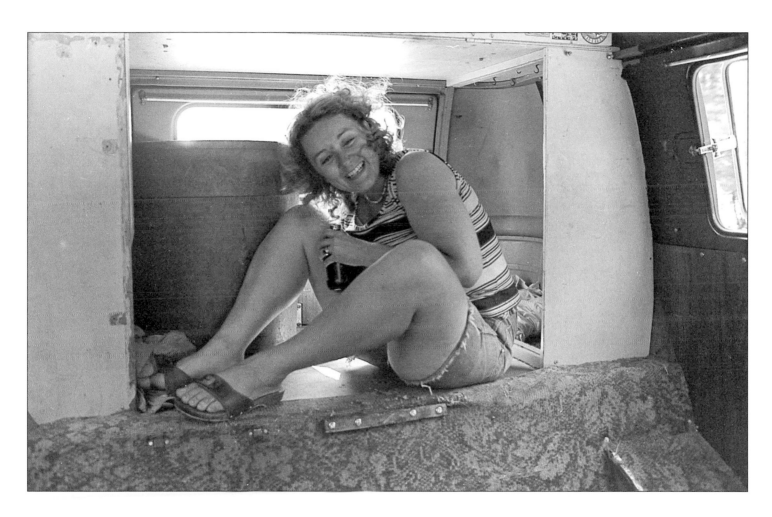

ABOVE: My first wife, Patricia, hanging out in the back of a friend's VW bus. OPPOSITE: Pat in our apartment. Pat's sister, Cathy, was married to Richard Picariello, who in the seventies landed himself on the FBI's Most Wanted List. He was linked to robberies, explosions, and threats of violence in Maine, New Hampshire, and Massachusetts. He was convicted and spent about twenty years in jail. I met him socially just a couple of times, but our apartment at the corner of Danforth and High streets was sometimes under surveillance. One morning the FBI knocked to ask questions. I had cut my hair, but a picture of me with long hair was on the wall, so they were very suspicious. When Cathy visited us, she came in the front door and disappeared out the back because she was constantly followed. During my wedding, the FBI sat outside and watched the apartment because Cathy was there. Some of my friends walked past them carrying a tall marijuana plant, but they didn't care. I guess they had bigger fish to fry!

One of my first photos that was seen by the general public. This is Michelle, who now lives in Florida. She was selling Kool-Aid on Munjoy Hill. This image once won $300 in a *Portland Press Herald* photo contest.

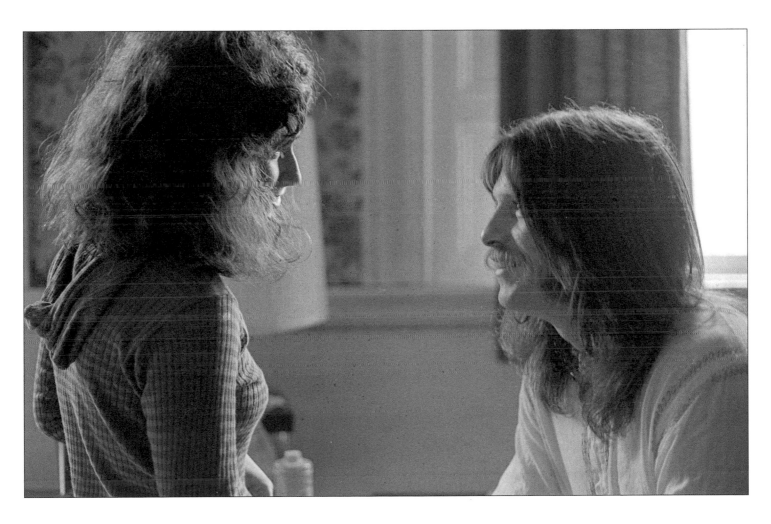

Kimberly Porter and Chris Porter. Pat and I got married at their apartment. At one point, Chris was a submarine man in the Navy.

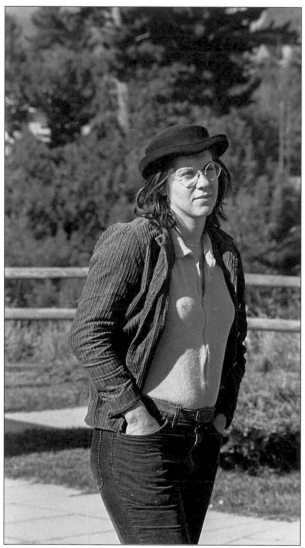

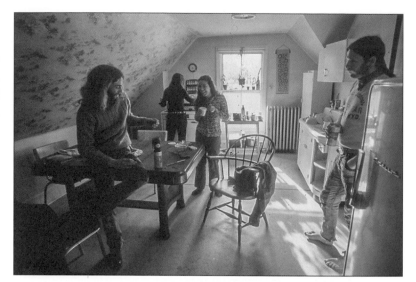

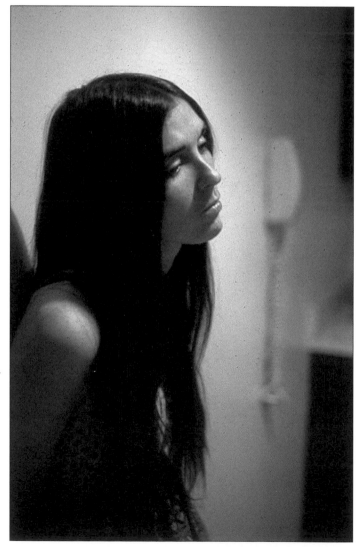

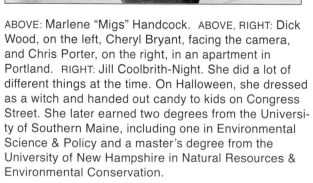

ABOVE: Marlene "Migs" Handcock. ABOVE, RIGHT: Dick Wood, on the left, Cheryl Bryant, facing the camera, and Chris Porter, on the right, in an apartment in Portland. RIGHT: Jill Coolbrith-Night. She did a lot of different things at the time. On Halloween, she dressed as a witch and handed out candy to kids on Congress Street. She later earned two degrees from the University of Southern Maine, including one in Environmental Science & Policy and a master's degree from the University of New Hampshire in Natural Resources & Environmental Conservation.

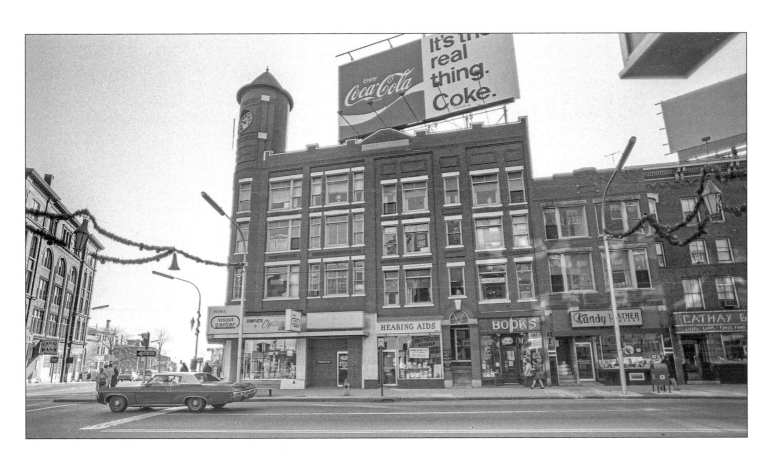

This is clearly taken sometime around Christmas along Congress Street. You can see the Libby Building on the left and Cathay Garden across the street. This image also highlights the large billboards that were once a prominent feature of the downtown landscape. The Libby Building was later torn down to make room for an expansion of the Portland Museum of Art.

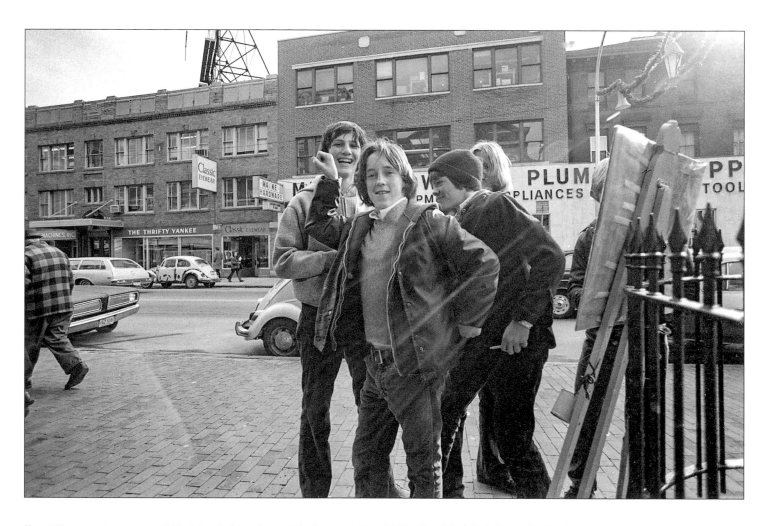

Tom Nixon and a group of his friends hanging out in front of the old Portland Public Library in the Baxter Building.

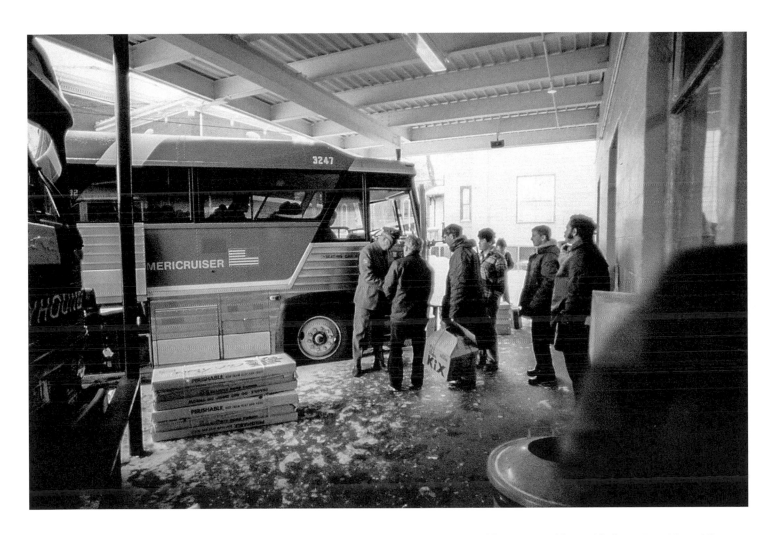

This is at the old bus station at the corner of Spring and High streets. I took a lot of fares to and from this bus stop. I loved it because you never knew who you were going to pick up and what their story might be. One night, I picked up a young woman at the station with her two young children. She was my age and newly divorced. She offered to pay my airfare if I would go to San Francisco with her to help her find an apartment and start a bike rental business near Golden Gate Park. I immediately agreed.

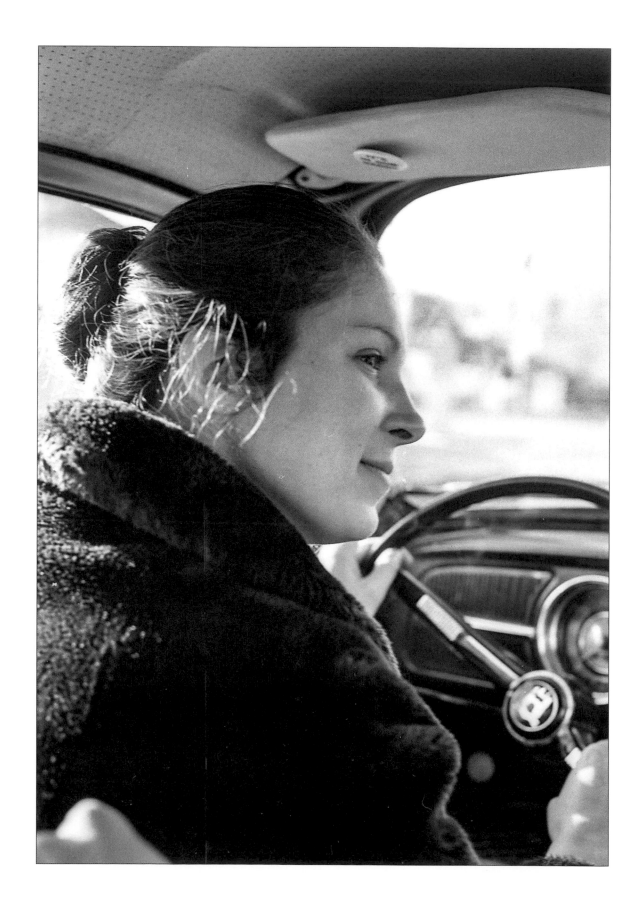

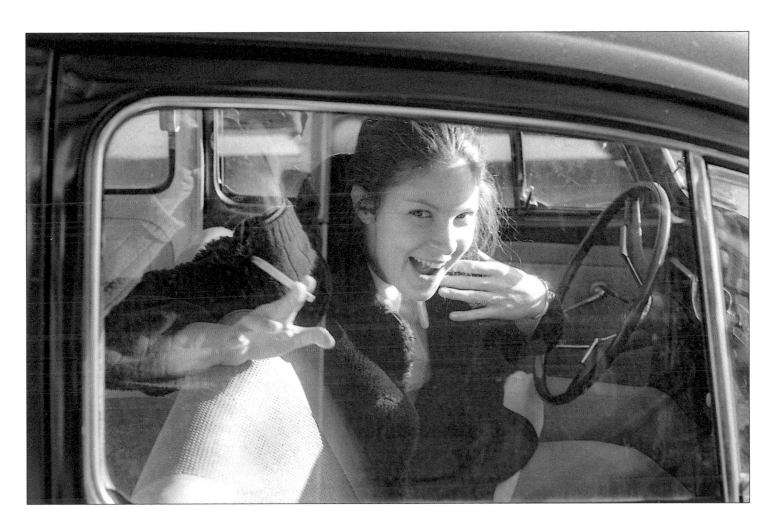

Marlene Chapman (above and opposite) at the wheel of her Volkswagen Beetle. Marlene loved life, friends, and rock 'n' roll. A mutual friend told me the two of them would dance under the trees at Deering Oaks and then walk across Tukey's Bridge to Falmouth Foreside.

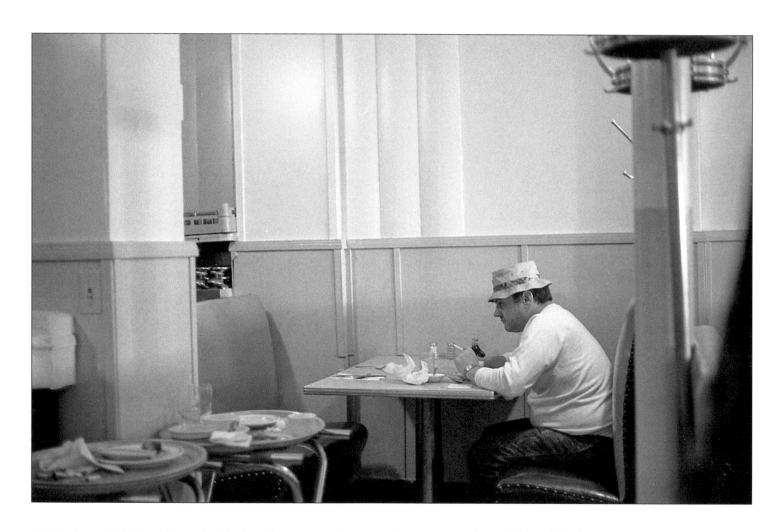

ABOVE: A man finishing his meal at Cathay Garden, which I remember as promoting a full lunch for $1.65. It closed in the late 1970s. OPPOSITE: Mary Jo "Dust" Keller was a free spirit who performed at the Children's Theater of Maine and worked in a lot of the restaurants around downtown Portland and the waterfront. Her sister, Jean, told me that she got the nickname Dust because she loved the phrase "ashes to ashes, dust to dust." She also loved to travel. Once, I was walking down a street in Fiesole, an Italian village overlooking Florence one day when someone yelled, "John!" And there was Dust sitting with some folks at a cafe there. What were the chances! Dust passed away in 2016.

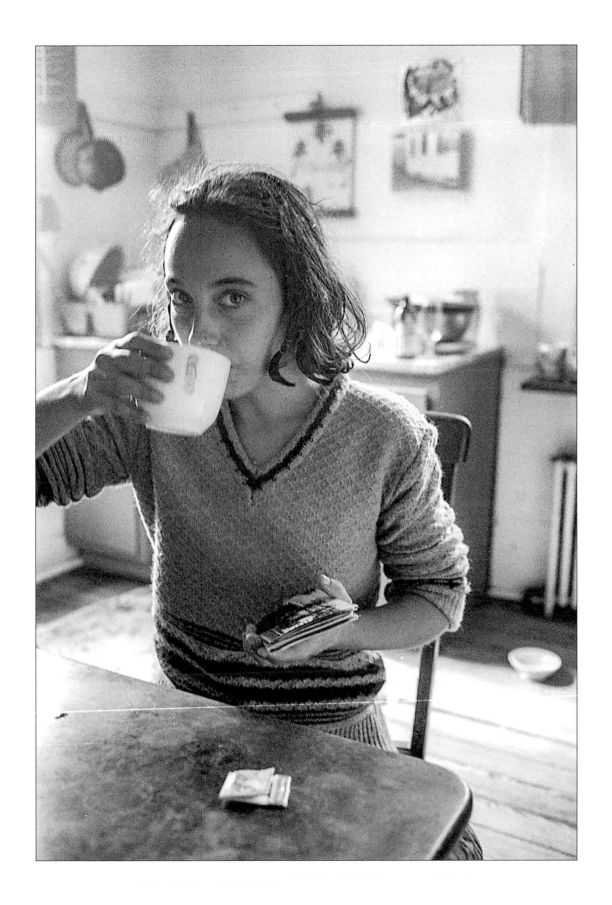

Carol (Hess) Kilgore and her son Ehben (a child with her first husband, Peter Eliot) at their house on Long Island. Carol was also married to poet Peter Kilgore, who helped develop the influential literary magazine *Contraband*, in Portland in the 1970s. Their daughter Shawnee is a folk musician based in Austin. Carol, Ehben, his brother Trent Eliot, and Shawnee's brother, Kalen Kilgore, now live in Washington state.

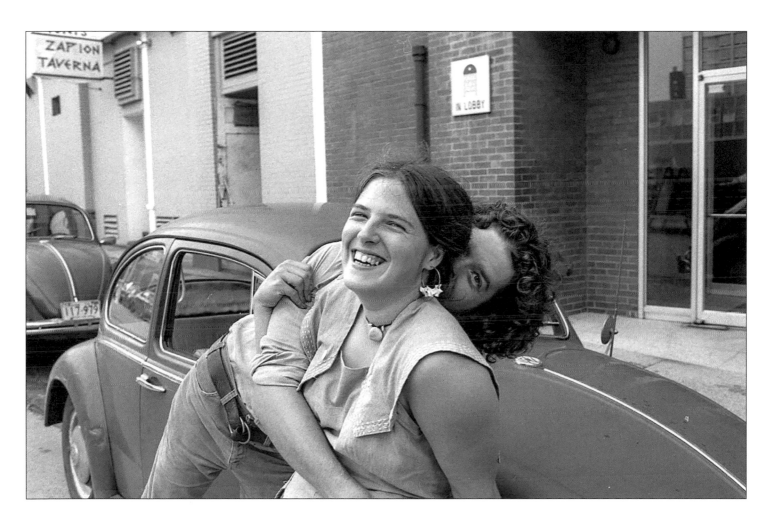

ABOVE: Beth Blood and Dana O'Donnell on Free Street. Dana was a great guitar player and fellow cab driver. OPPOSITE: Marie Graffam as a young girl on the West End. Marie contacted me on social media to let me know this was a picture of her. So cool!

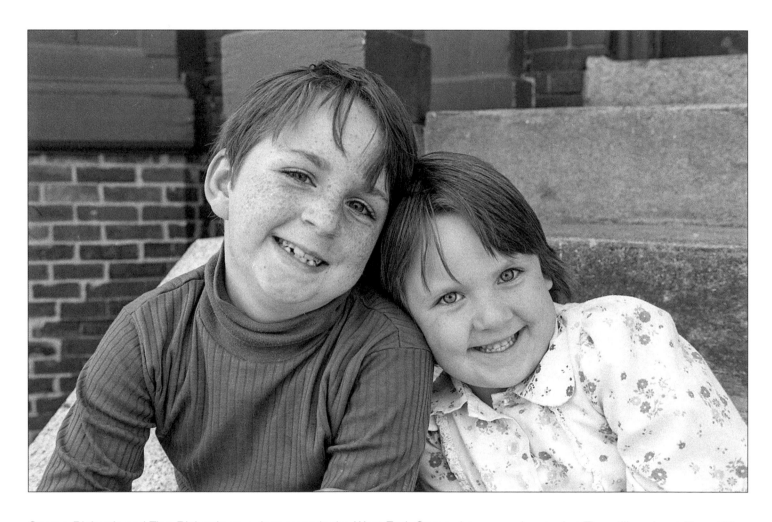

George Richards and Tina Richards on a door stoop in the West End. George has passed away, but Tina still works at Pizza Villa.

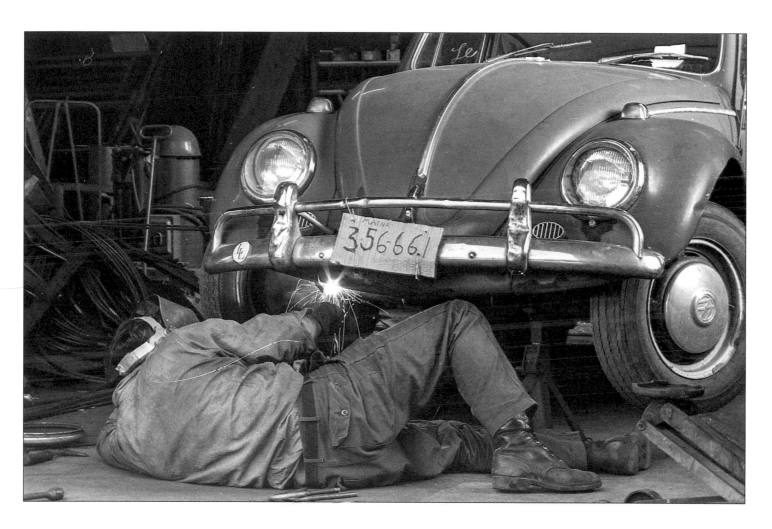

The guys at Lenny's Garage working on Dana O'Donnell's 1966 VW, cardboard plate and all. Dana graduated from Deering High School in 1968.

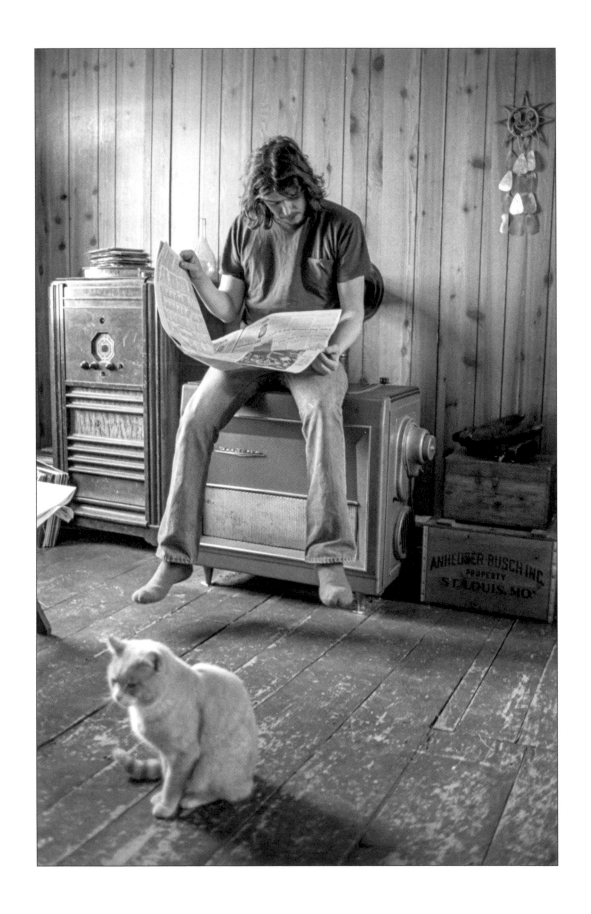

Memories

I love sharing old photos. I love the joy people get from seeing an old friend. I love reminiscing about Portland. I also wonder about the people in these images that I have lost touch with. I wonder what they are doing. I have reached out and reconnected with some. That has been a great joy! I can't do that with everyone. Some of my old friends who look so young and vibrant in these images passed away much too young.

I see a young man like Dick Wood, with his long beard enjoying an afternoon on a sailboat, but I also know that he worked as a painter and one day fell off the scaffolding and died from the injuries. I know Roger Sabin's brother Quentin "Chip" Sabin was fishing with a rod from a small boat in Casco Bay that capsized. He tried to swim to shore, but didn't make it.

Some of the people who have passed away, I lived with and even worked for in a pinch. Christopher "Chris" Grasse, a photographer and dancer, was tall with flowing long hair. He died in 2011 at the age of 68. Chris was easy to spot. He walked with a rhythm that made him stand out amongst other pedestrians. When I was sitting in my taxi outside of Paul's Food Center, Chris often hopped in the cab with me to just ride around as I picked up fares, always adding his unique insights into any conversations that arose. We passed the nights riding through the streets of Portland together. He was a great photographer. In the late sixties, he opened a popular portrait studio on Exchange Street, but it was vandalized so badly in 1971 that he had to close it down. He learned to play the piano and church organ by ear. He loved cycling and animals. He was always helping the elderly, the poor, and the homeless. I can remember him dancing at bars and parties just seeming to enjoy himself, even though I know he grew depressed at times. I miss his wit and charm.

James "Jim" Ledue died in 2009. He was 57. When Susanne and I moved back from Sweden in 1987 with our two young boys, we lived with Jim on Emery Street. I worked at his restaurant Alberta's until I found another job. He and I worked on oil rigs in Wyoming together and both lived in a local bunkhouse. He hitchhiked across Canada and ended up in New Mexico for a while. But when he came back and started his restaurants in the 1980s, he helped introduce Portland to culinary trends, such as mesquite wood grilling and "death by chocolate." His breakfast spot, The Good Egg, was a trendsetter. As were Alberta's and Bella Bella. Jim's travels and curiosity fueled his culinary vision. He was also fueled by a spirit of creativity and generosity. He opened his restaurants to the homeless and traded meals to those who couldn't afford them.

Roger Sabin, probably my best friend in the seventies, died in 2004. He was only fifty. Roger worked as a bartender at Pizza Villa for twenty-five years. He was great at it. He was quick-witted, a great talker, and had a breadth of knowledge to help carry any conversation. His obituary said he honed his gift of repartee on his customers, some of whom became lifelong friends. That is true. I lived with him on Brackett Street for a while. It was great fun! He graduated from Deering High School in 1970 and attended the University of Southern Maine. I was never much of a sports fan, but Roger loved playing softball, volleyball, and golf. In his final years, he was stricken with crippling neuropathy. After he died, I inherited his vinyl collection and I donated it to WMPG. He was meticulous when it came to handling his albums!

OPPOSITE: My dear friend Roger Sabin reading a newspaper in his Bracket Street apartment near the hospital. That is his cat, "Pud." I lived with Roger in this apartment for a while.

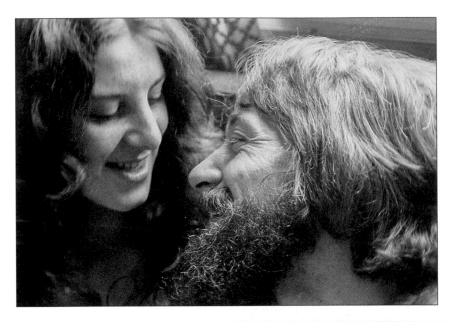

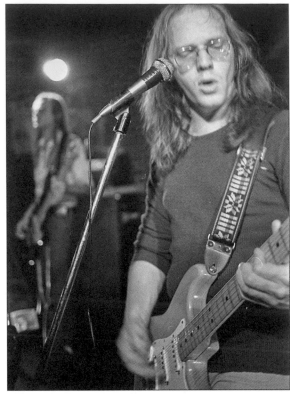

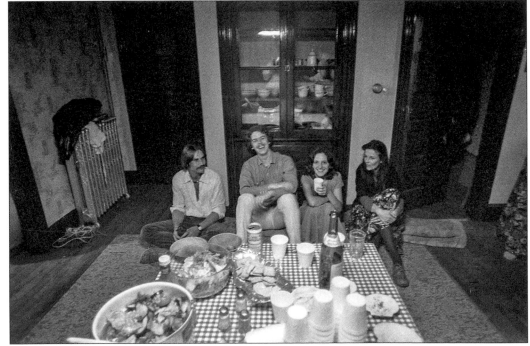

ABOVE: Christy Fales and Bob Lebreque. Christy and I both drove cabs for Yellow Taxi (I also drove for Town Taxi). The Yellow Cab garage was located on Forest Avenue where The Great Lost Bear is now. ABOVE, RIGHT: Bob and George of the Big Roll Band at the Rook and Pawn. RIGHT: Brad Blanchard, Roger Sabin, Jean "Sam" Keller, and Angie Blanchard at my wedding on Brackett Street. OPPOSITE: Betsy in her polka-dot dress. Betsy is holding a bottle of Wild Irish Rose with her feet, outside of some apartments that were created at an old church.

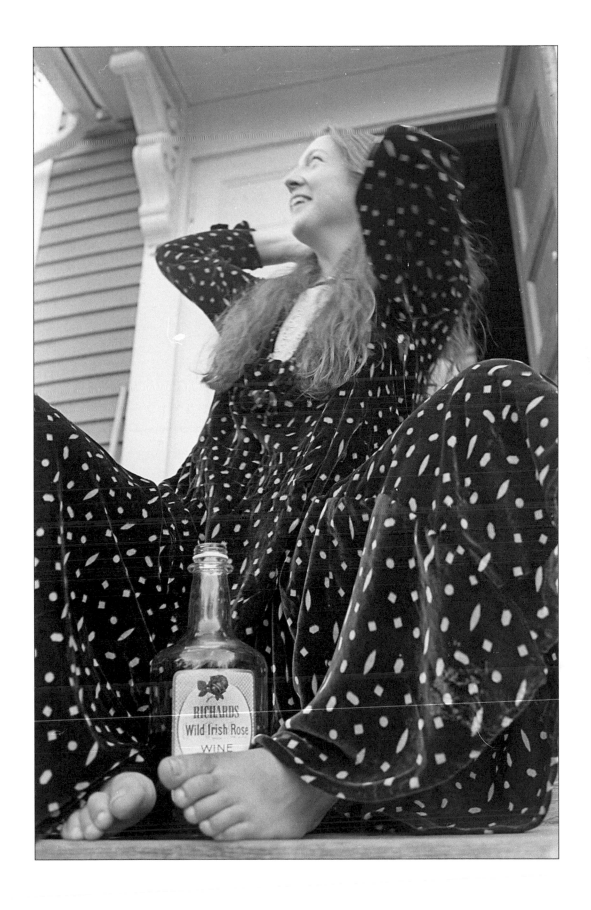

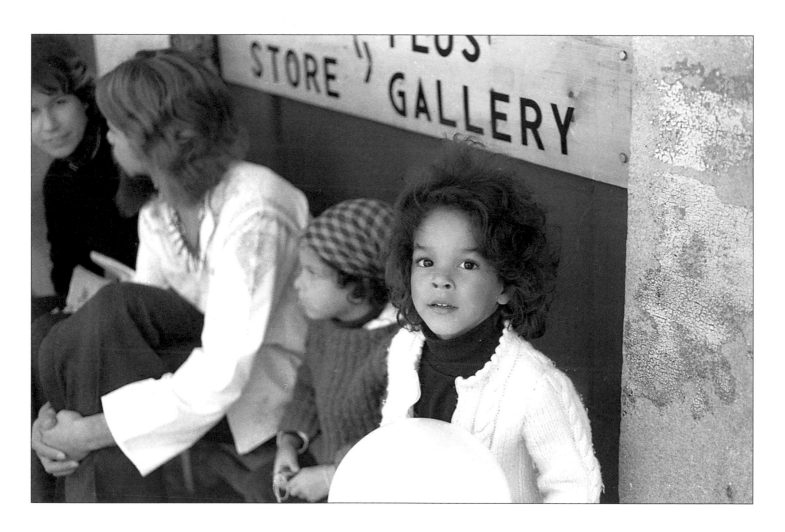

A young girl holds a balloon at the Old Port Festival. It was a great event that started in 1973. The bands would play all night, and so would we.

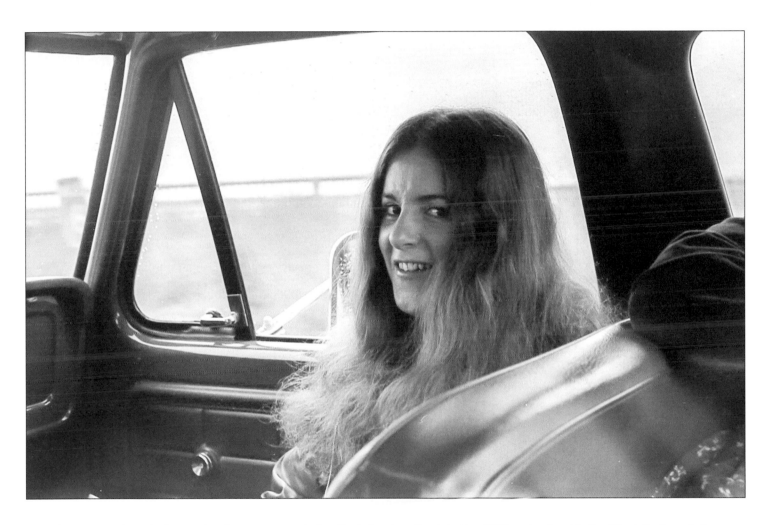

Judy Strout, my sister-in-law at the time, was married to Pat's brother, Paul. In the 1970s, she lived in the West End, and she now lives in South Portland.

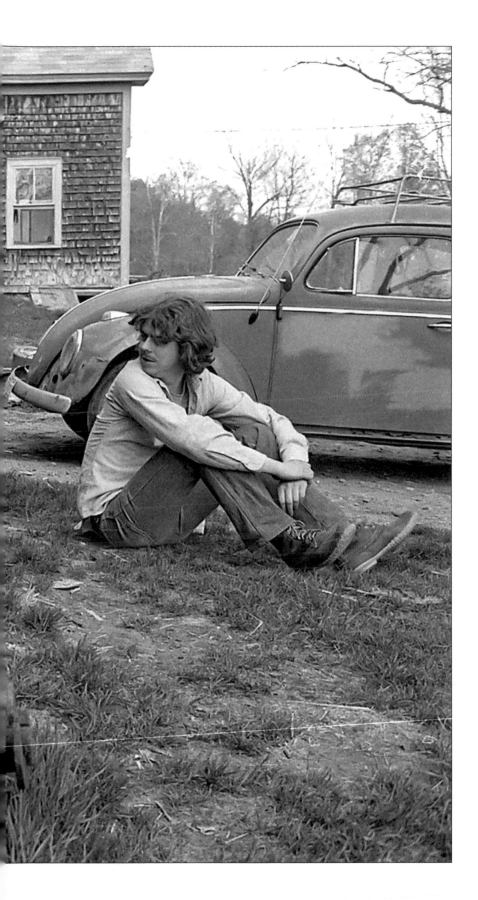

Roger Sabin, one of my best friends, is sitting on the ground next to the VW. I am not sure where this was taken. Roger was only fifty when he passed away in 2004. When he died, his sister Becky called me from the hospital so I could come see him one last time before they moved him. I gave him a kiss on the forehead and bid him farewell. I spoke at his service. Every Fourth of July for years I knocked on his door at six in the morning with a case of beer and we would party the day away! Later, when I was away from Portland traveling either in the United States or Europe, I always called him on the Fourth to keep the tradition alive. In his memory, I still call Becky on that date every year.

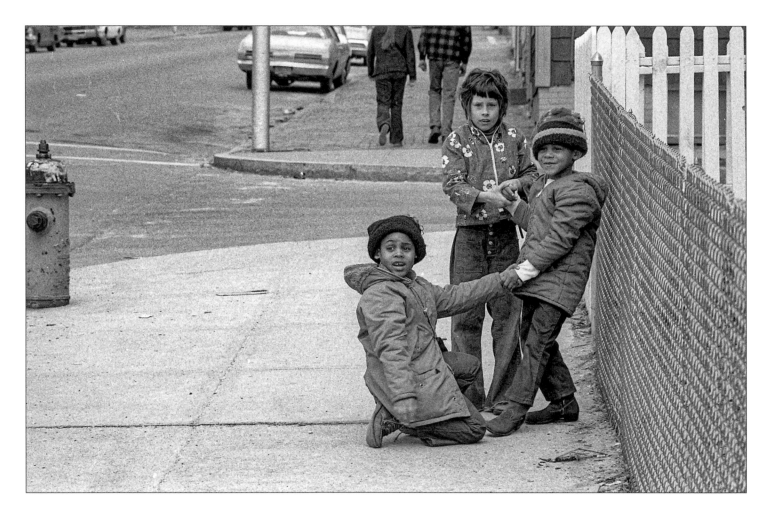

ABOVE: Three kids playing on the sidewalk in the East End. OPPOSITE: Chris Porter in his Brackett Street apartment on his wedding day. Chris drank a lot and read a lot, including *The New York Times* cover-to-cover nearly every day. Old Milwaukee was a popular beer with us because it was cheap. Chris and I often hitchhiked to rock festivals together.

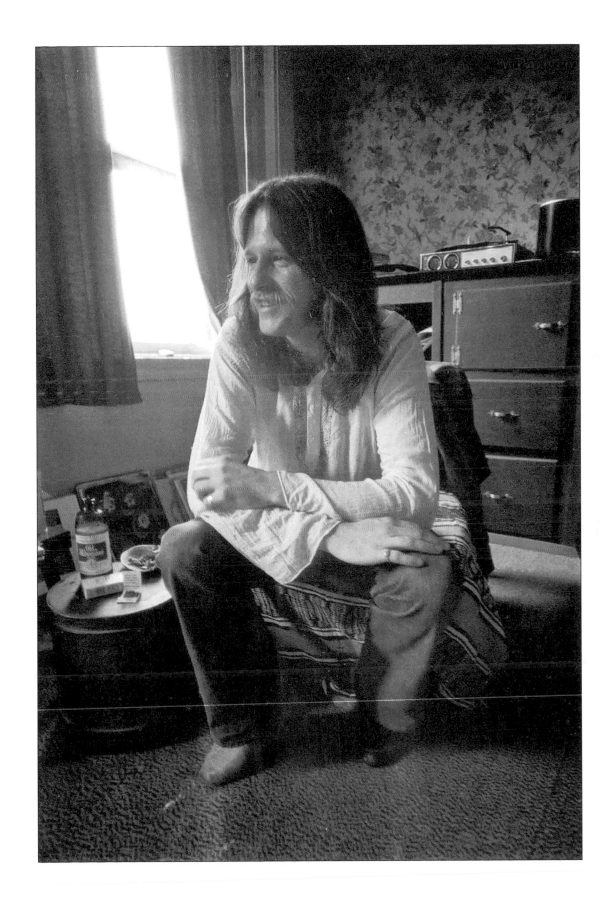

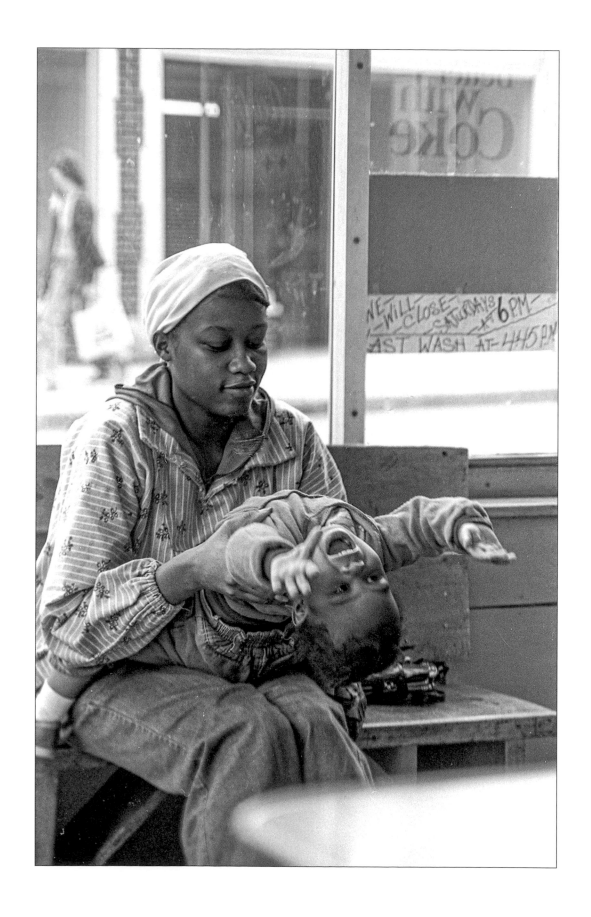

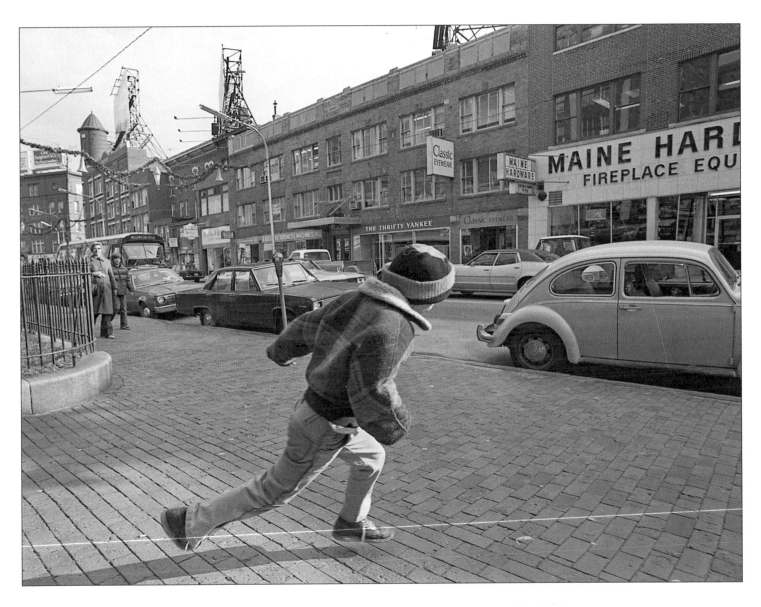

ABOVE: Sometimes when taking pictures I would find a spot and just sit. I would shoot whatever happened over the course of a few hours essentially using the same background. I did that a couple of times in front of the old Portland Public Library.
This boy seems in a hurry to get away from something. OPPOSITE: I took this photo while doing my wash at Longfellow Laundry. This woman was waiting for her wash to finish.

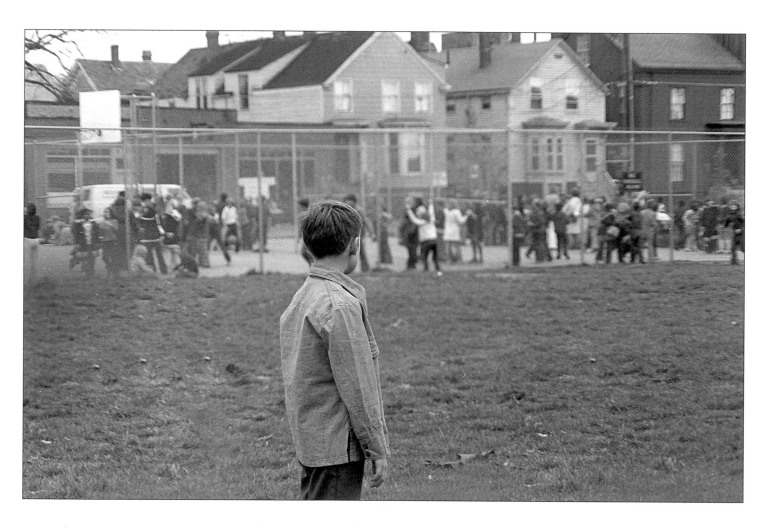

ABOVE: I am not really sure what was going on, but this picture has a great mood. Perhaps the boy was looking longingly at the other kids playing at Reiche School in the West End, but was not allowed to join them. OPPOSITE: This is me in my long, long hair days, hanging out at Union Station Plaza on St. John Street.

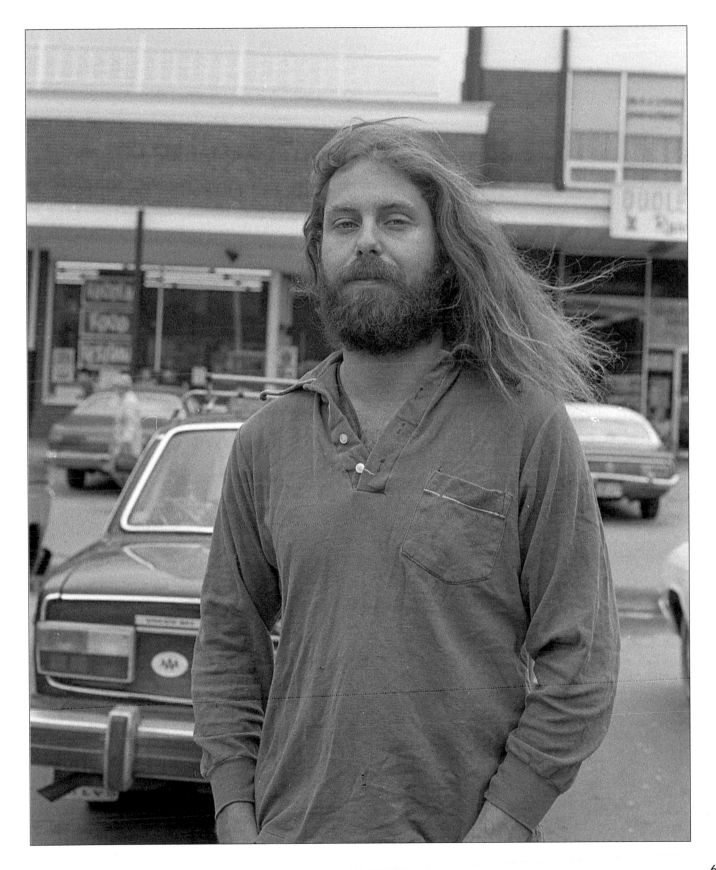

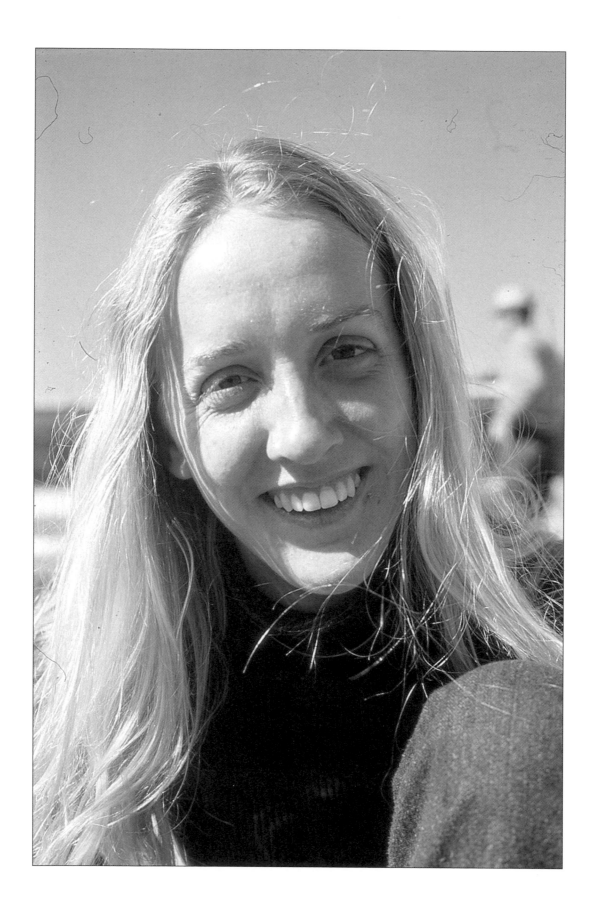

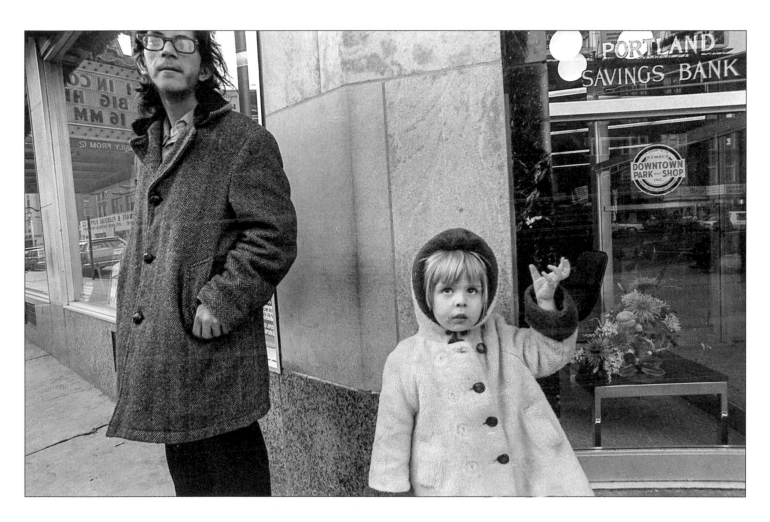

ABOVE: Another image I captured during a walk around the city. I sometimes shot "fast and furious" as I walked. This was on Congress Street. I love the look on the girl's face and the position of her left hand. OPPOSITE: June McCartney. I mentioned earlier I was a hopeless romantic. June and I had an intense two-month relationship. She was an artist from New Jersey and she took me there to meet her family. We came back to Maine together, but split up a little while later.

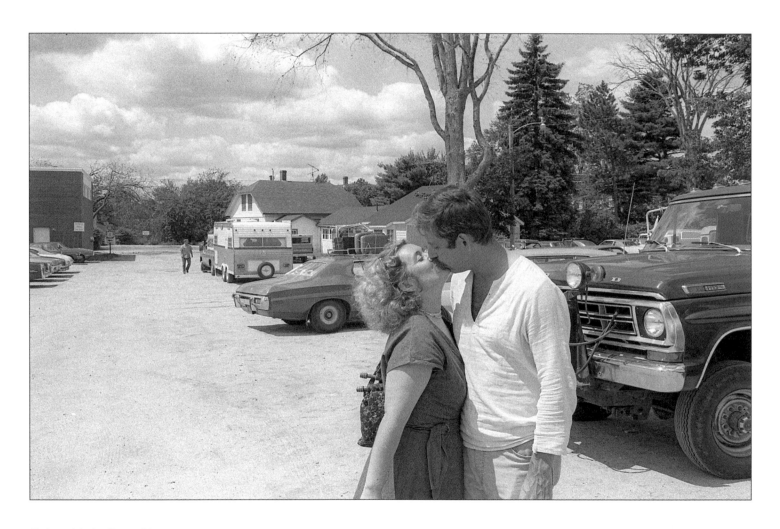

Pat and I stealing a kiss.

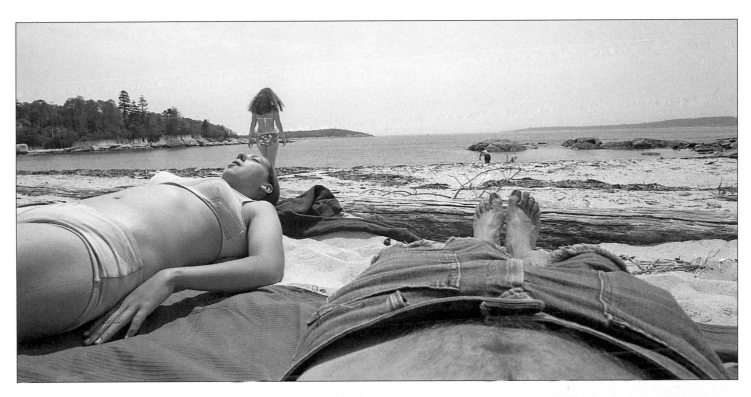

ABOVE: Hanging out at
Fowler Beach on Long
Island. Those are my toes.
RIGHT: Jean "Sam" Keller.
FAR RIGHT: Dick Wood

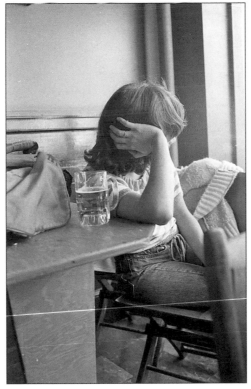

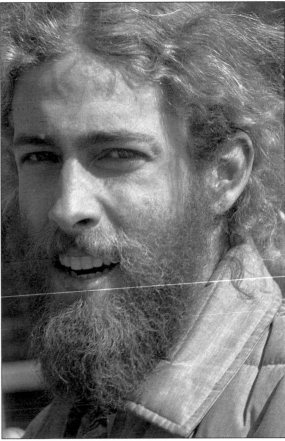

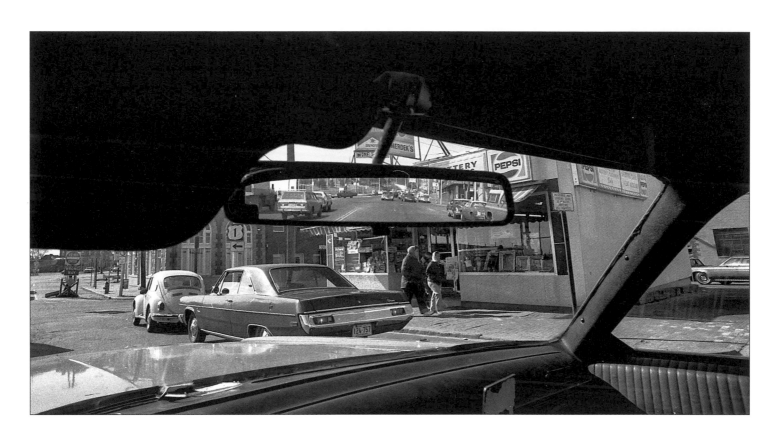

When I was driving my cab, I almost always had my camera with me and would shoot whatever caught my eye.

Work

In 1987, I returned to Maine after eight years in Europe with Susanne and our two boys. In Portland, this time with a family, I settled down and found a steady job. I worked at Locke Office Products for fifteen years. In 2004 I got my CDL and I drove a truck for another fifteen years, including a stretch as a long-haul trucker. It was fun to see the country from the driver's seat, rather than as a hitchhiker.

My resumé during the seventies was a different story. I started, quit, and returned to many jobs. Often I just picked up work where I could. My jobs included driving a taxi cab, washing dishes, toiling as a farmhand and cook for a Scientology-connected school, pumping gas at a truck stop, shoveling mud at an oil rig in Wyoming, working as a deckhand on the Casco Bay Lines, collecting garbage in Portland, and working on B-52 bombers in the US Air Force.

I even joined the circus. Ringling Brothers came to Portland on a train and parked on the tracks along Commercial Street. I wandered down and asked for a job. They hired me to sell cotton candy. I ran back to my apartment, stuffed what I could fit into a backpack, and hit the road to travel with the circus. My new home was a bunk bed in a train car. It was a fascinating introduction to an amazingly diverse and interesting group of people. I remember people in small towns stepping out of their cars to wave at train crossings. During one long haul to Oklahoma, I remember sitting on the steps between two train cars, having a smoke, and watching America roll on by.

Regardless of where I wandered, I always returned to Portland.

For a while, I also collected garbage. A friend, Tom Handcock, was hired by Portland to collect food waste. He would pick me up in the morning and we'd work in a different neighborhood every day. Residents left small, galvanized garbage cans by their doors. We dumped the contents into fifty-five-gallon drums that we carried in the back of an old bread delivery truck. When we were done, we drove out Longwoods Road in Falmouth and gave the garbage to a local pig farmer.

My favorite job was driving a taxi. I worked a twelve-hour shift from four in the afternoon to four in the morning. It was great. I could take pictures, I met fascinating people in the wee hours of the morning, and I could leave for an adventure and always come back. The job gave me a true street-level understanding of Portland.

Besides driving a taxi, I most often worked as a dishwasher at local restaurants. I had a good reputation and good dishwashers were hard to come by, so I could usually find work. At The Skillet, a lunch counter at Grant's on Congress Street, there was a trapdoor behind the counter that led to the basement. They sent down dirty dishes, I cleaned them and sent them back up via a dumbwaiter. I also washed dishes at restaurants like Horsefeathers, F. Parker Reidy's, The Splendid Restaurant, and George's Delicatessen.

Unfortunately, George's was one place that I did not leave on good terms. I was living on Winter Street with two friends and we didn't have much money, so they loved it when I brought home George's tomato soup and other yummy things. My problem was that the other dishwasher was a relative of the owner. I felt the kid was useless. Usually when I arrived for my shift, the dish area was a chaotic mess and I had to fix it. I am even-tempered, but eventually I just lost it and quit. I hurled the large dish rack like a frisbee through the kitchen, and stormed out.

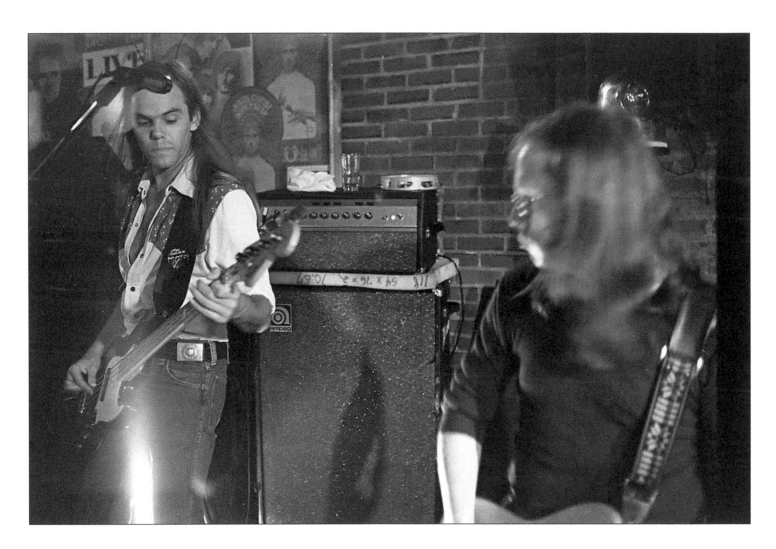

The Big Roll Band at the Rook and Pawn in Portland.

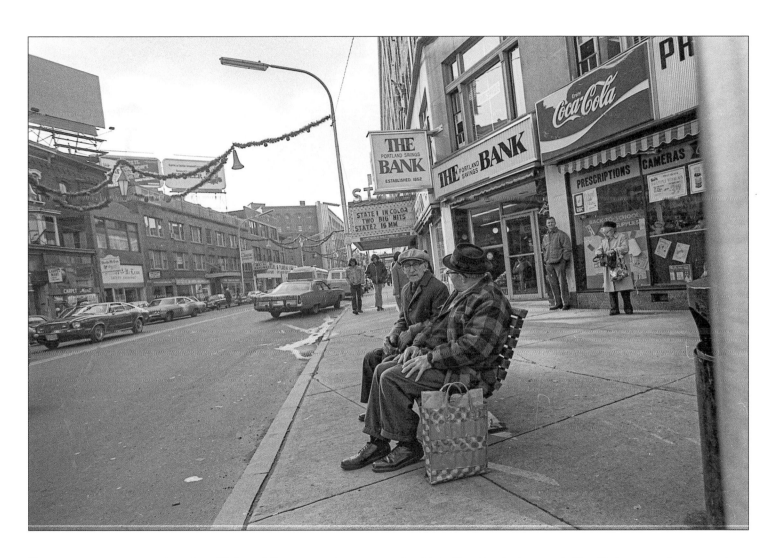

Two men converse on a bench at High and Congress streets, near the State Theater, facing west. The State opened as a movie theater in 1929 with 2,200 people attending Gloria Swanson's "The Trespasser." By the 1960s, the theater fell on such hard times that it was in danger of being torn down. To save the building, the owners leased it out to show porn movies. It was still a porn theater when I took this photo. In recent years, the historic building has been restored.

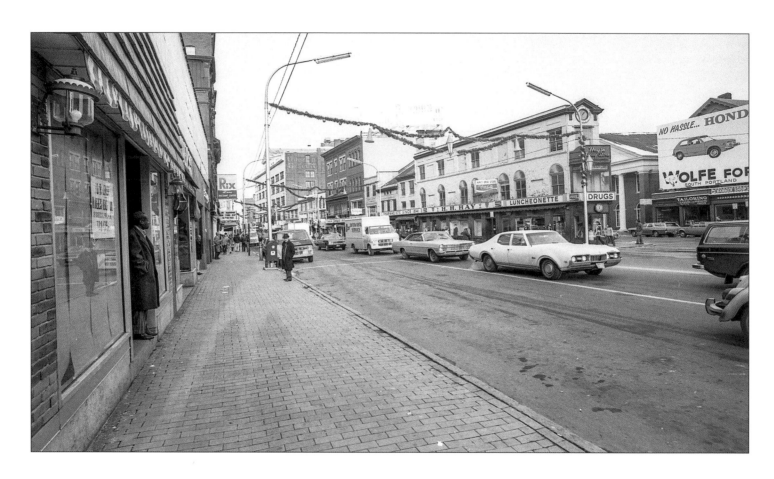

ABOVE: This photo is looking east from Congress Square. You can see the H.H. Hay building, an iconic flatiron-style building that was built in 1826. It was placed on the National Register of Historic Places in January 1978 and saved from demolition.
OPPOSITE: A young girl collecting donations for the Drum and Bugle Corps. This may have been at Union Station Plaza.

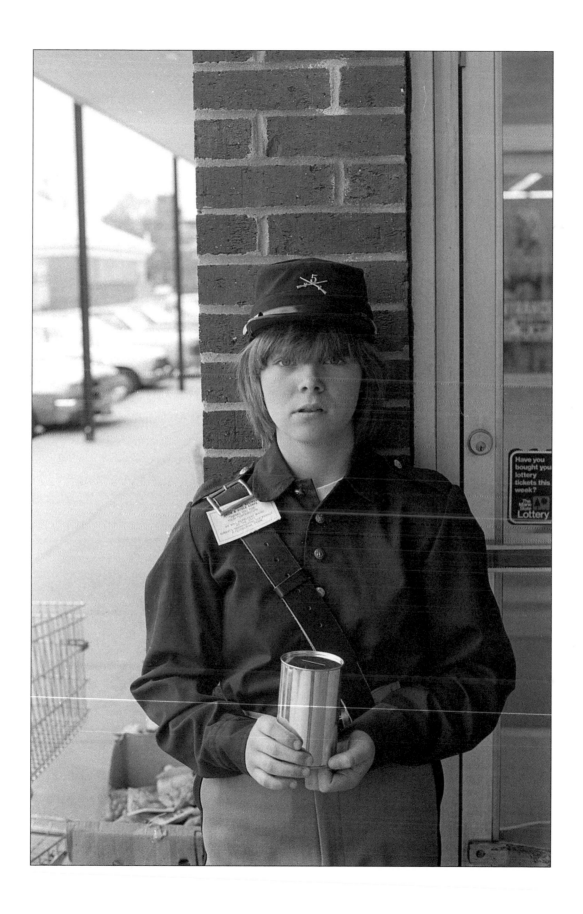

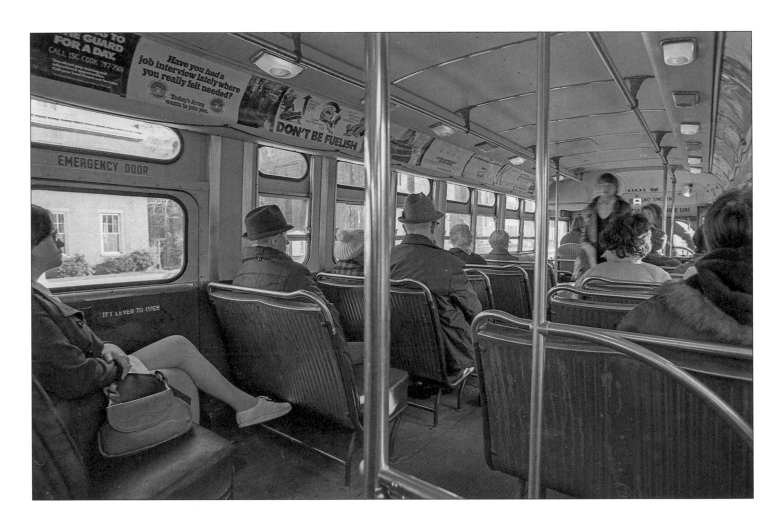

People riding the Portland Metro, probably during the gas crisis in 1973 judging by the "Don't Be Fuelish" sign. I wasn't riding the bus, I just stepped inside the open back door during the stop to quickly snap this photo.

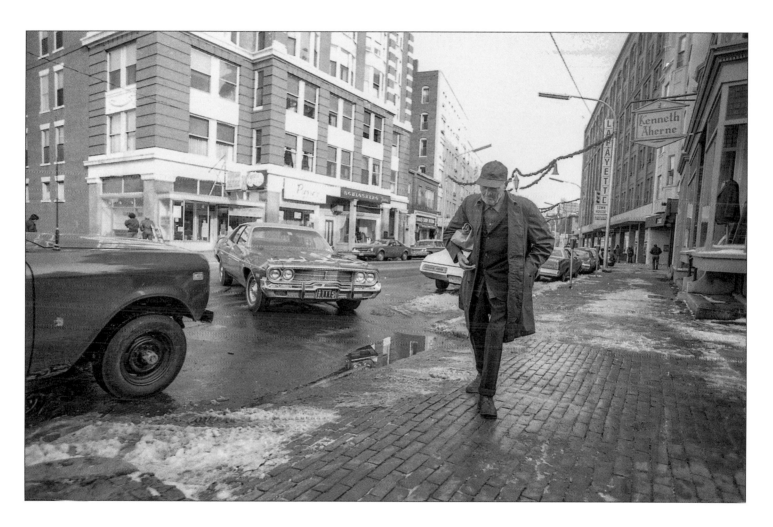

An elderly man walks past Kenneth Aherne's Tailor Shop at 660 Congress Street. You can see a sign for Lafayette Town House, known as Lafayette Hotel until 1967. It was built in 1903 and named after the Marquis de Lafayette, a key ally of George Washington. The luxury hotel included 162 hotel rooms, a billiard hall, a large dining room on the seventh floor, and its own pharmacy on the Congress Street side, called the Lafayette Drug Store.

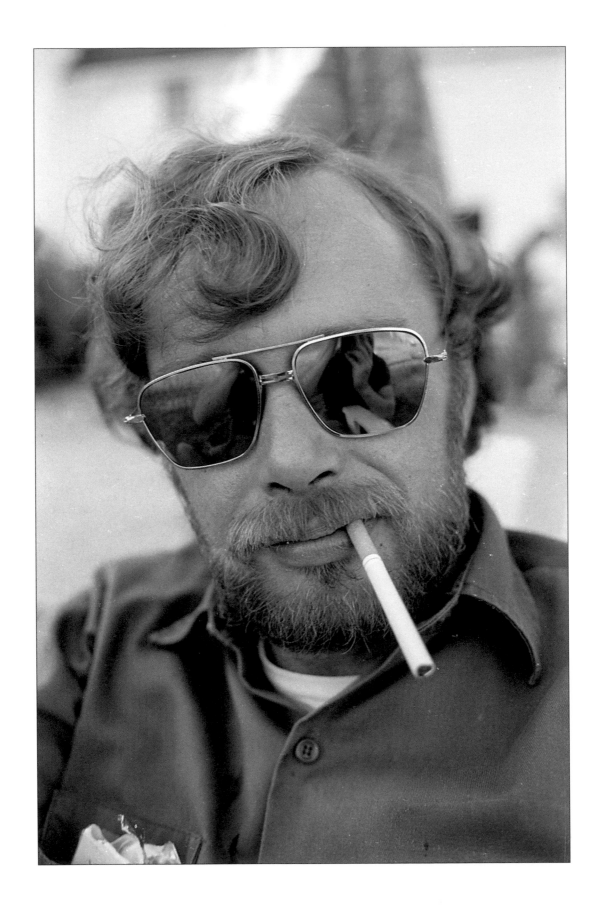

ABOVE: A young boy giving me a sideways glance as he walks past a window of Porteous, Mitchell and Braun, the great downtown department store. I was just walking down the street and snapped this image. I probably didn't even break stride. OPPOSITE: Instead of a mirror, I shot my reflection in this guy's glasses. We were at a picnic for The Wise Guide.

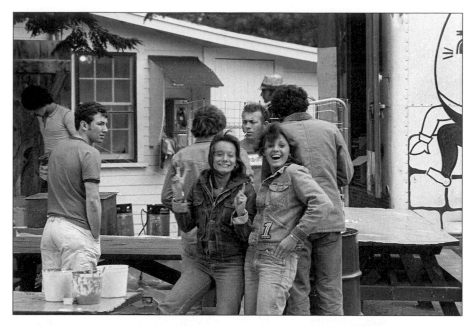

One year, I spent a day shooting photos at the Freakers Ball rock concert at White's Beach Campground in Brunswick.

LEFT: Two women pose in front of a Humpty Dumpty potato chip truck. BELOW, LEFT: Steve Hanks points as he stands next to Officer Arnie Murdoch. BELOW: Cheryl Sprague and Bill Day.

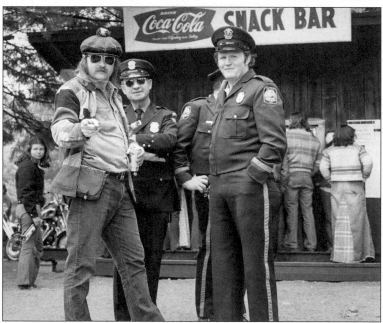

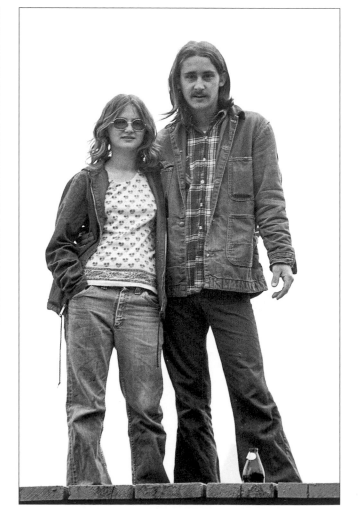

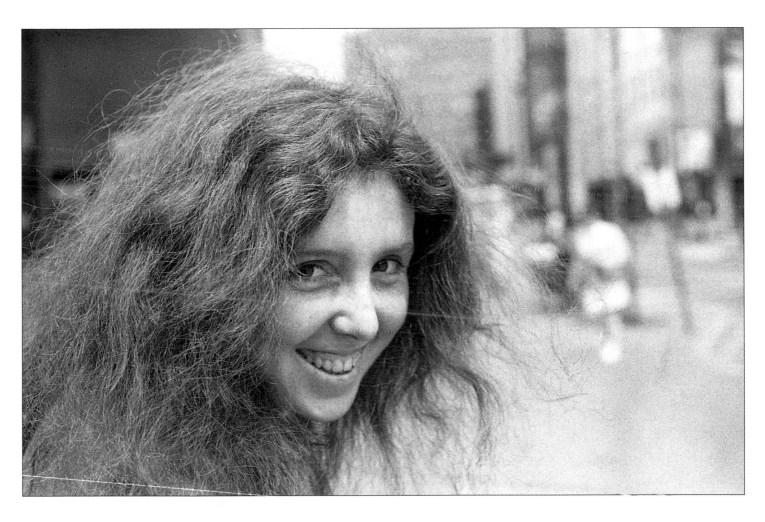

Sandy Boivin, wild hair and all, on Congress Street.

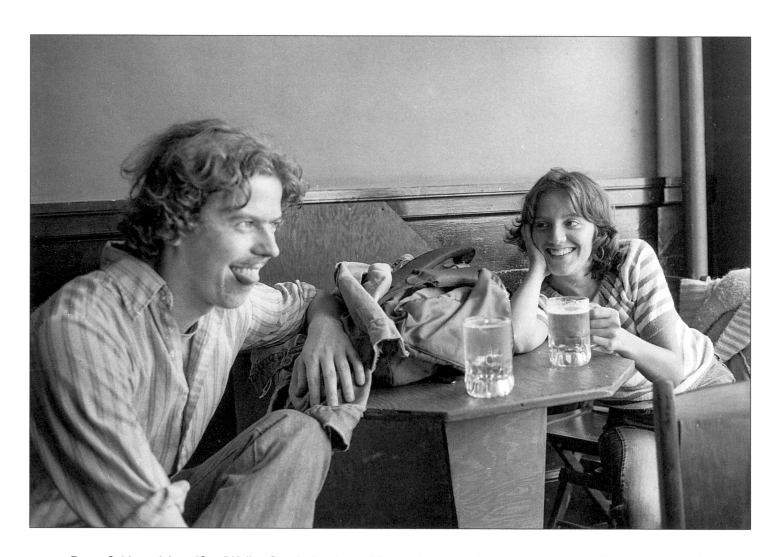

ABOVE: Roger Sabin and Jean "Sam" Keller. Sam is the sister of Dust, who graces the cover of this book. Sam was married to Roger for a short time. When Roger died, I inherited his vinyl collection and donated it to WMPG. It was a great collection and he was so meticulous when it came to handling his albums! OPPOSITE: Chris Grasse, a terrific photographer, dancer, musician, and artist. Chris would often hop in my cab and ride the night away as I picked up fares. He carried on a conversation with everyone I picked up. This picture was taken at my wedding. He passed away in 2011.

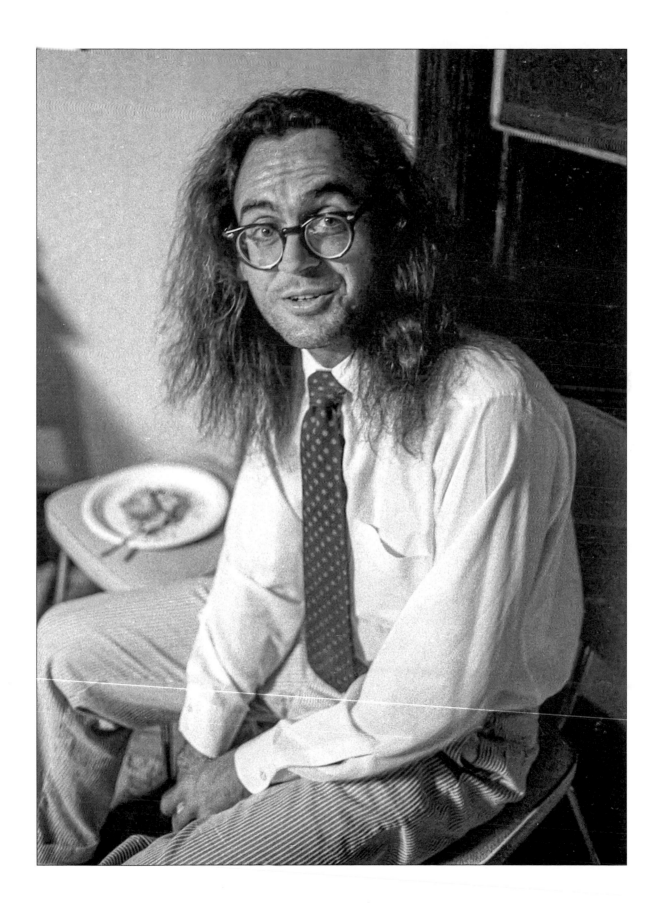

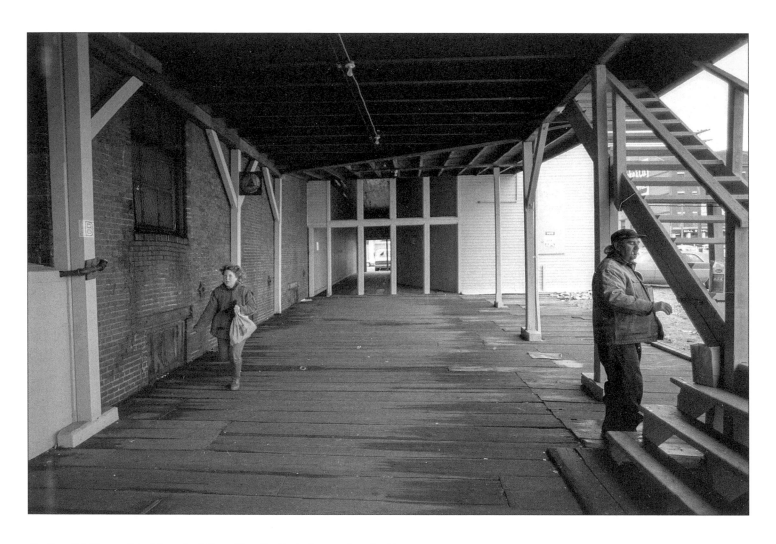

By the old Casco Bay Lines building. The Porthole is now located here.

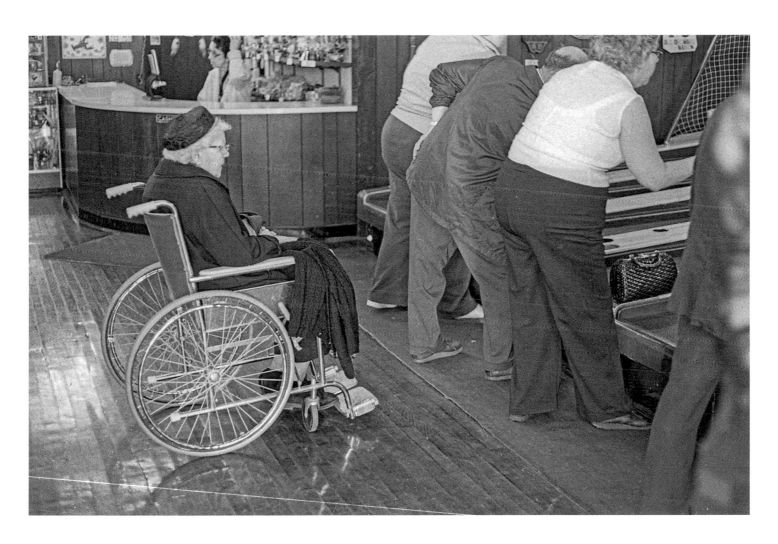

An elderly woman watches people play Skeeball at Old Orchard Beach.

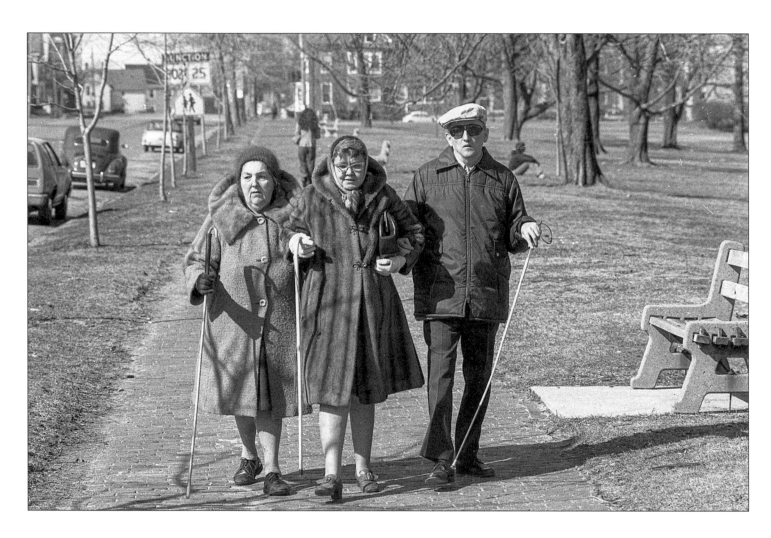

This photo was taken looking west along Park Avenue. That's Deering Oaks on the right.

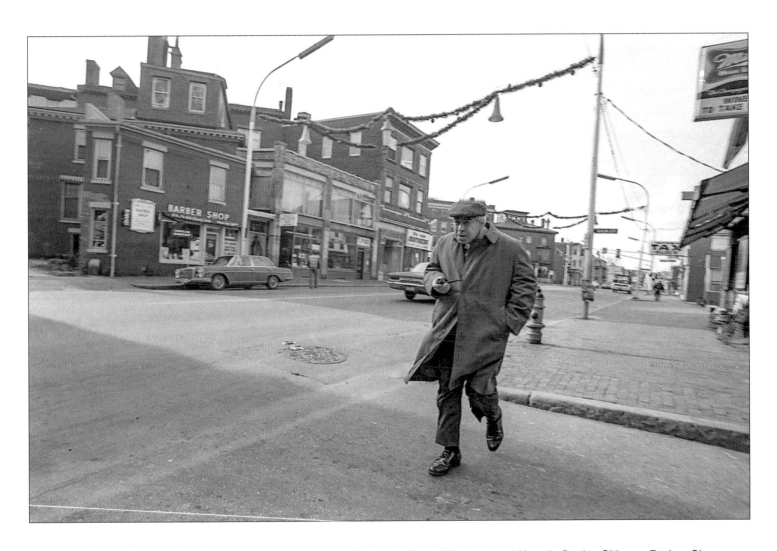

A man, holding a pipe, hustles through an intersection on Congress Street. You can see Norm's Senior Citizens Barber Shop across the street. Norman Millette opened the shop in 1959. It was called Longfellow Barber Shop and he wanted to offer a discount for senior citizens in the Yellow Pages. They wouldn't print it, so he just changed the name to Senior Citizens Barber Shop.

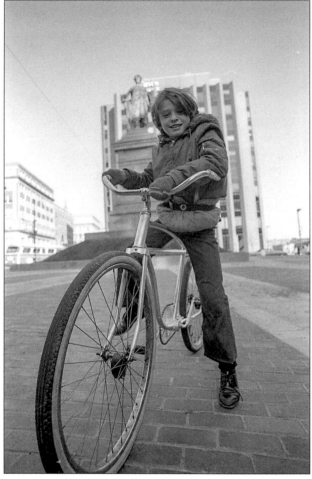

ABOVE: A young girl wearing what may be a mood ring. I probably didn't know her. Just taking images of random children around the city is not something you could do today, but in the seventies it seemed fine. ABOVE, RIGHT: A child just having fun, riding a bike in downtown Portland. RIGHT: A group of young friends outside Portland Public Library on Congress Street. I have been told the kids include Timmy and his sister Tammy, Clyde, and a friend.

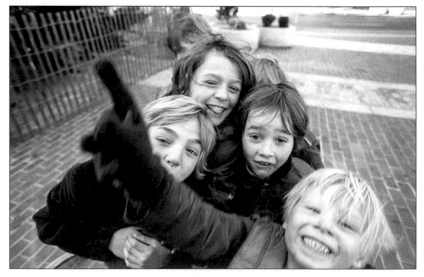

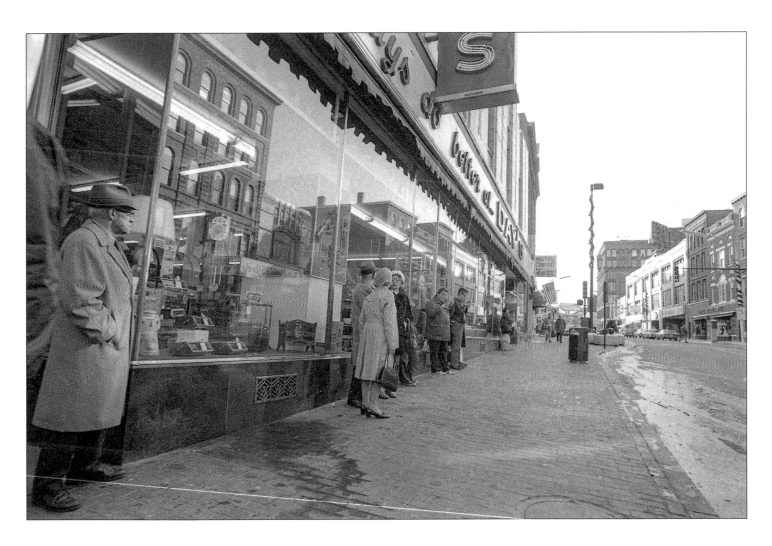

A man, looking stern outside of Day's Jewelry store, stares west down Congress Street. You can see a sign for Hotel Everett on Oak Street. The hotel opened in the 1940s and featured fifty-five rooms and boasted that every room had hot and cold running water. It is now housing for the Maine College of the Art.

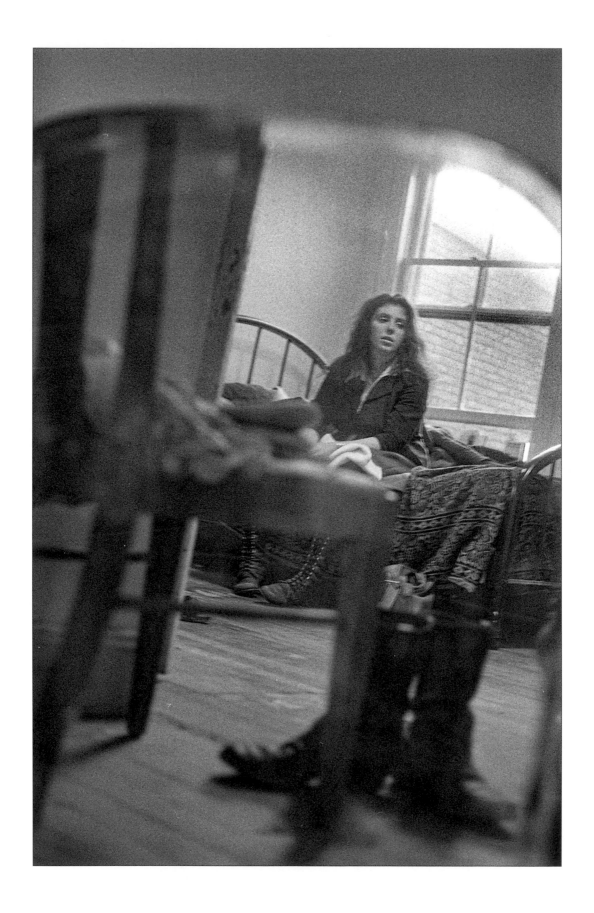

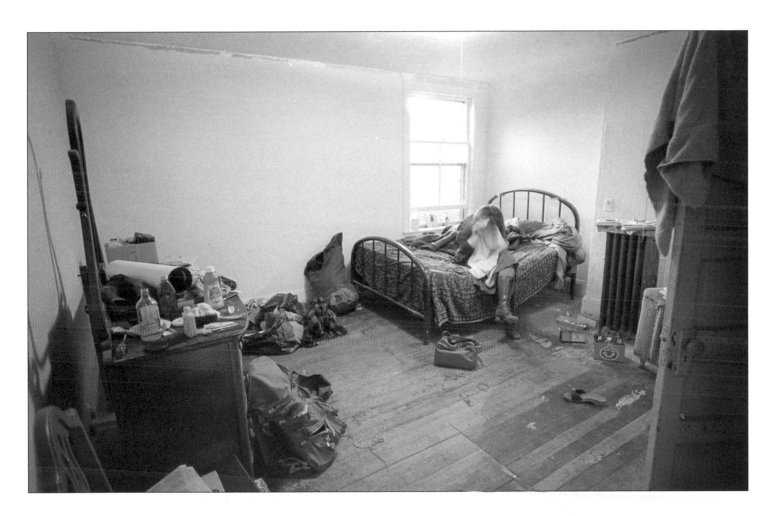

ABOVE AND OPPOSITE: Sandy Boivin at her apartment in Portland. Sandy and I hitchhiked together from Maine through part of Canada to San Francisco. In South Dakota, we were picked up by a trucker, "Watermelon Man," who hauled melons from Florida. He was taken by Sandy and wanted to sit next to her, so we switched seats while roaring down the highway and suddenly I was behind the wheel and he was next to Sandy. He started hitting on Sandy, but she could handle him no problem. I drove until the next truckstop and we hopped out. In San Francisco, we got a place for a short while, but when she started a relationship with a local man, I headed home. I never saw her again.

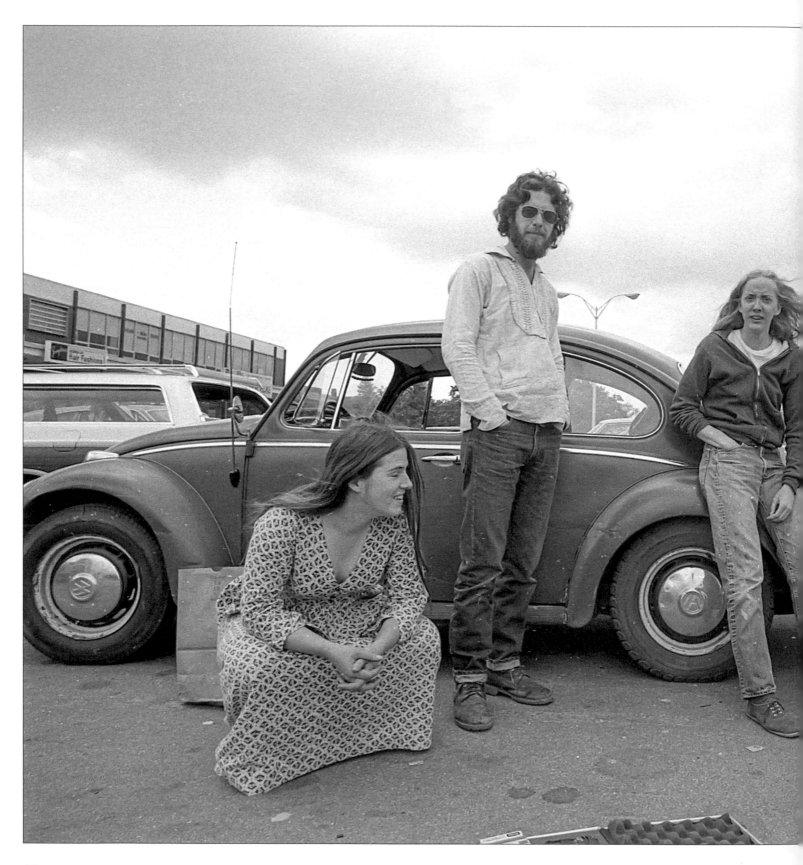

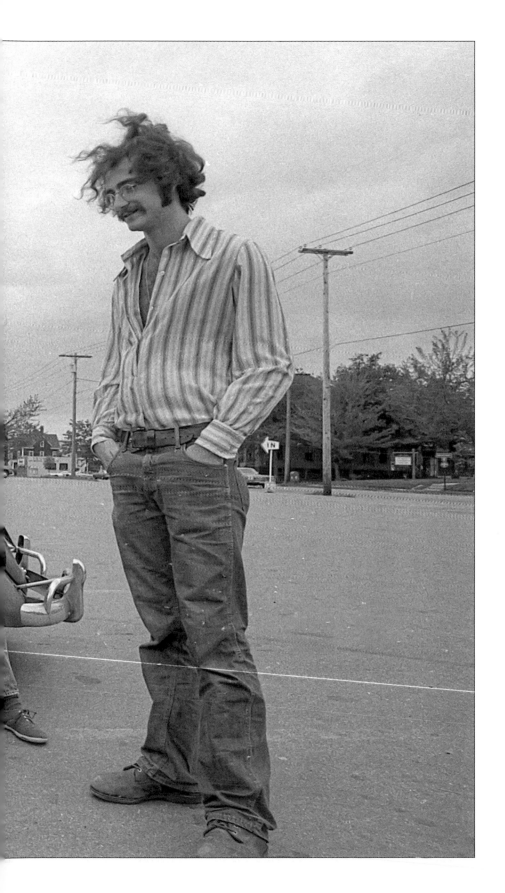

To me this image just epitomizes the seventies.
Beth Blood, Dana O'Donnell, June McCartney,
and John Read in front of a Volkswagen Beetle
at a plaza on Forest Avenue.

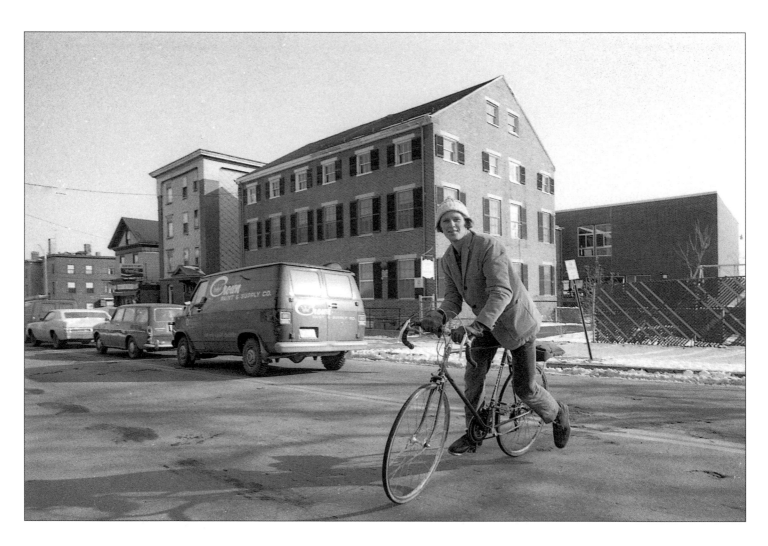

ABOVE AND OPPOSITE: James "Jim" Ledue. For a short time, Jim and I worked on oil rigs together in Wyoming. Jim was later instrumental in establishing Portland as a foodie town with his restaurants, one of which was The Good Egg Café. When Susanne and I moved back to Portland from Sweden in 1987 with our two young boys, we stayed with Jim on Emery Street. I worked at his restaurant, Alberta's, until I found another job.

ABOVE: This old guy looks like he has some stories to tell. OPPOSITE: Denise Luttrell at the Old Port Tavern. Denise was part of a band (and was known as Rockin' DeDee, I am told) and was married to Steve Luttrell. Steve says he fell in love with her voice, even before he fell in love with her.

Tom Handcock. Tom and I worked together at Shaw's in Falmouth as teenagers. As an adult, I worked collecting garbage. Tom had a contract to pick up food waste, so each day he picked me up and we worked in a different neighborhood. We used a former bread delivery van and we dumped the discarded food into fifty-five-gallon drums that we kept in the back.

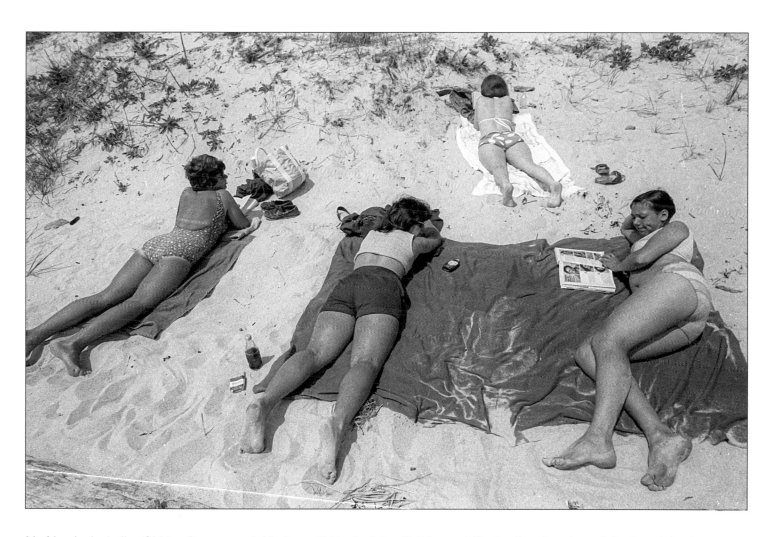

My friends, including Shirley Connor, and, I believe, Shirley's sister, Kathleen, at Fowler Beach on Long Island, an island town that used to be part of Portland. Shirley has lived on Long Island for as long as I can remember. We met when I worked for Casco Bay Lines. She taught school in Portland for about forty years.

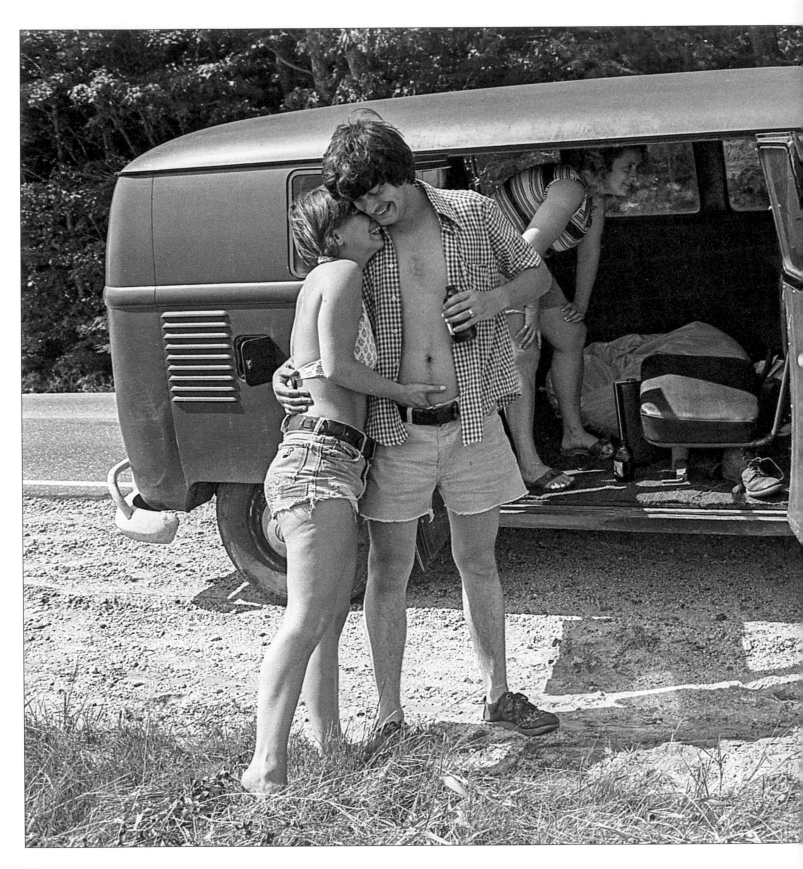

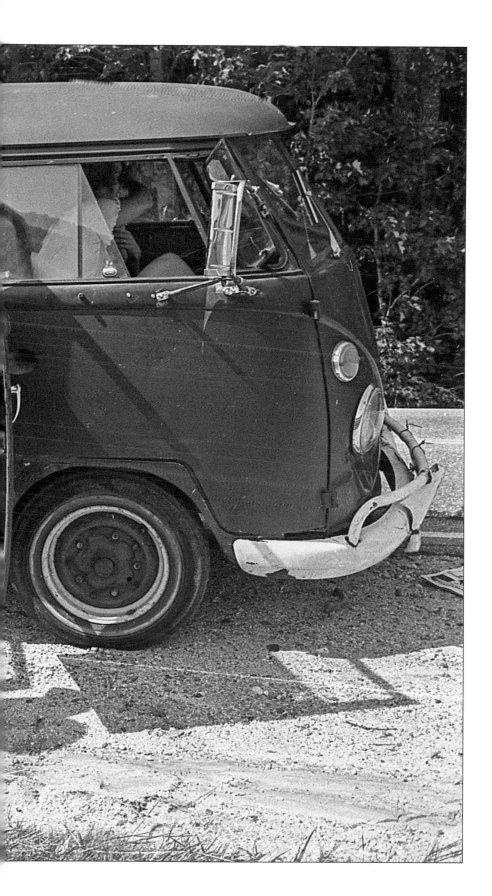

Pat Strout is inside the van. The couple standing outside are Jim Handcock and his girlfriend, Patti Rainville.

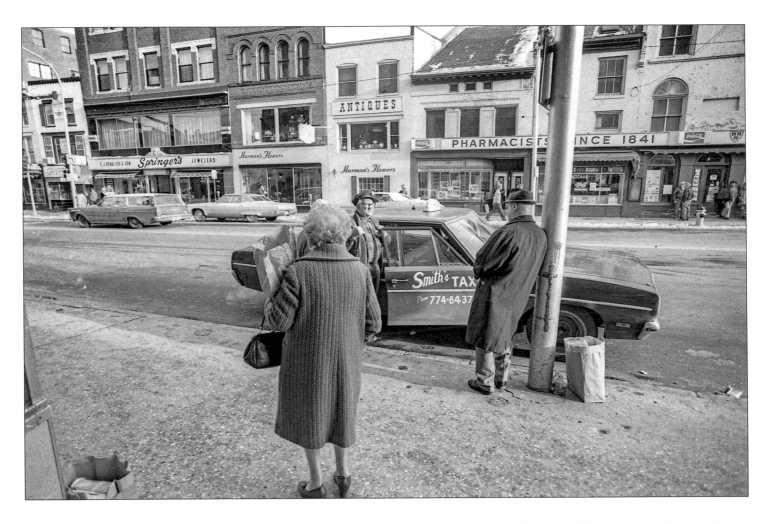

A cabdriver for Smith's Taxi waiting for a fare outside of Paul's Food Center. You can see Harmon's Flowers across the street. I often parked my cab here waiting for a fare and would take photos of what was happening around me.

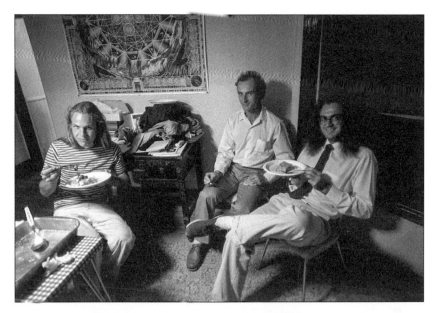

LEFT: This is at my wedding. The trio is Steve and Jim Priestly, who are brothers, and Chris Grasse. Jim and Chris have both passed away. Steven has created cover art for *The Café Review*. BELOW, LEFT: I shot this inside a candle-making factory in the Old Port, probably the one owned by Henry Willette, which was in the first wave of new businesses to start bringing back the Old Port as a tourist destination. BELOW: Pizza Villa sponsored a softball team in the 1970s. Adult softball leagues were popular, probably in part because you could drink and smoke while playing! That is Roger Sabin with the Yankees hat and cigarette.

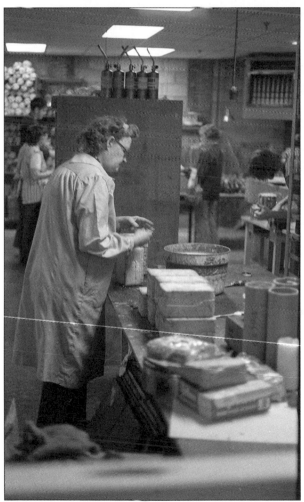

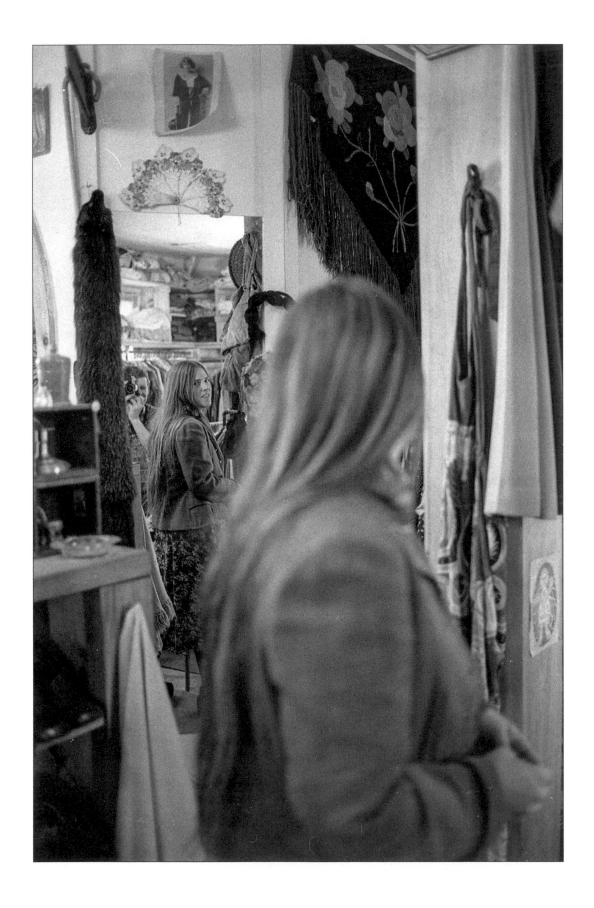

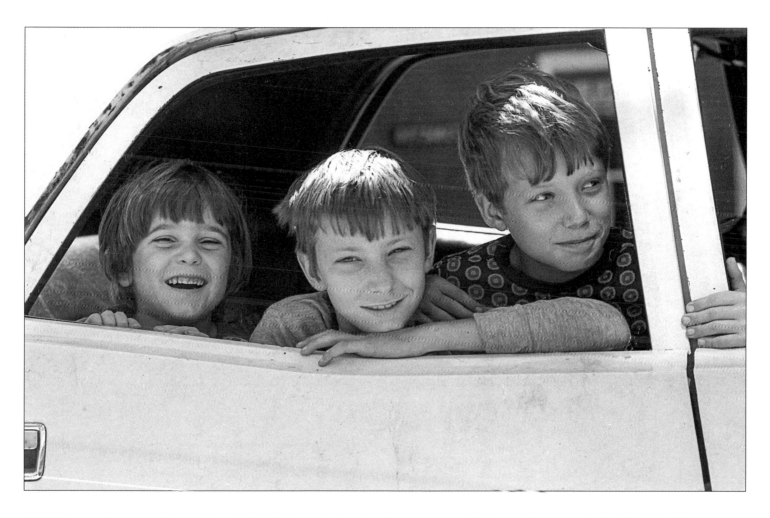

ABOVE: I sometimes would experiment with photography by choosing a very specific type of image and shooting lots of them. I took many shots of people in car windows as the cars were stopped at a light or a stop sign or when they were parked for a minute. OPPOSITE: Beth Blood at Sunshine Surplus & Salvage, where she worked in the seventies. In addition to being a musician, she was also a seamstress who later opened her own business called Suitsme on Pleasant Street.

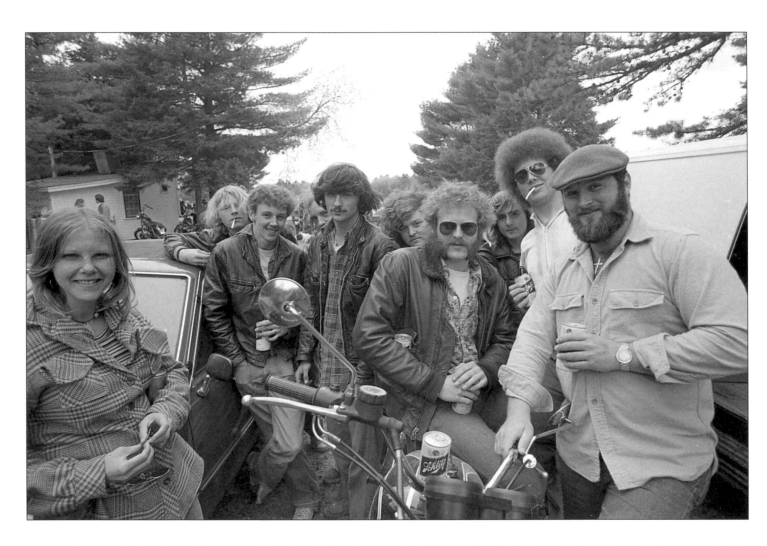

ABOVE: A group of attendees at the annual Freakers Ball rock concert at White's Beach in Brunswick. By the end, the concerts attracted more than 3,000 fans each year. The concerts were stopped in the early 1980s after a fight ended with one person getting fatally shot and two others wounded. OPPOSITE: Owner Al Neal tossing a pizza at The Pizza Joint on Forest Avenue. The family still owns the restaurant.

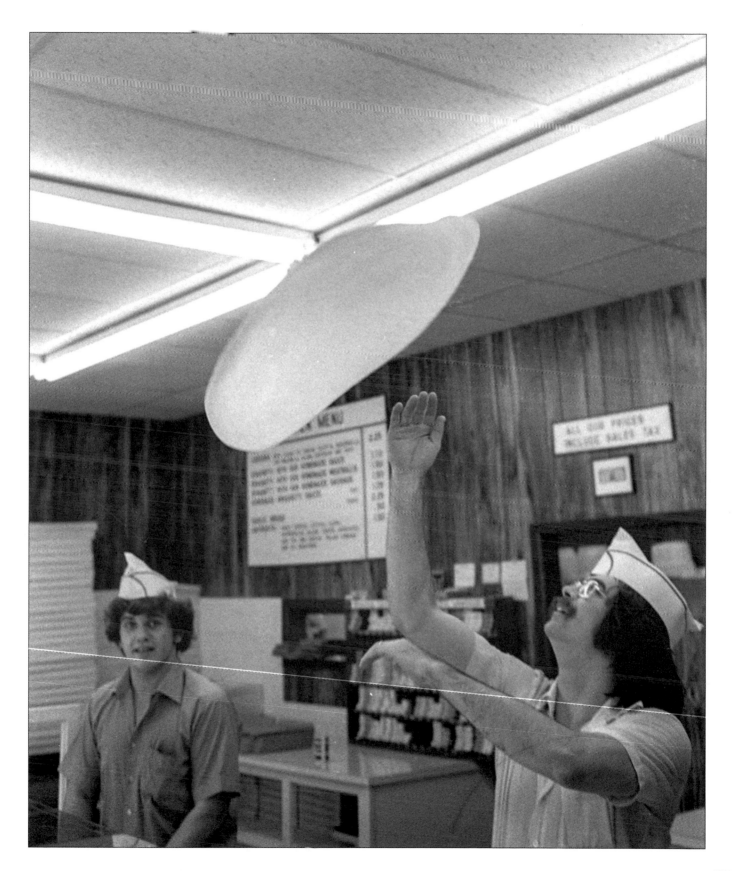

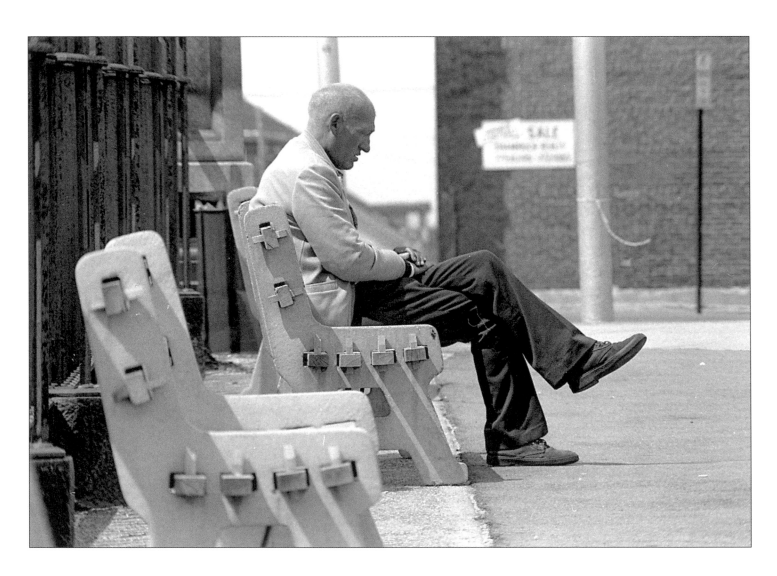

A man rests on a bench, probably along Cumberland Avenue.

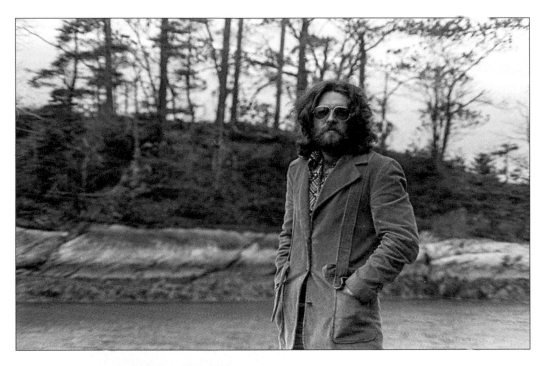

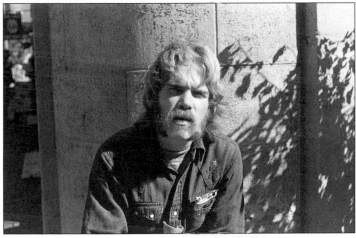

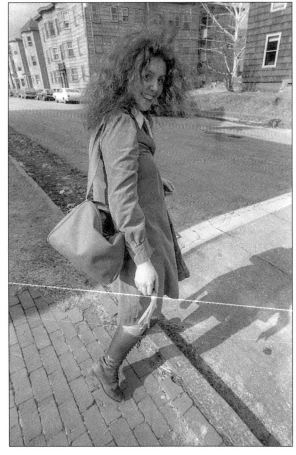

ABOVE, TOP: Paul Strout, my former brother-in-law. He was married to Judy Strout. ABOVE: This is Lenny. In 1969, Lenny was one of two strangers who, after they learned I owned a car, approached me on Congress Street to ask if I would drive them to Montreal so they could buy some drugs. I had just graduated high school and I agreed. At one point on the trip, I was being strip-searched while staring at a portrait of Richard Nixon. It was a wild trip.
RIGHT: Sandy Boivin.

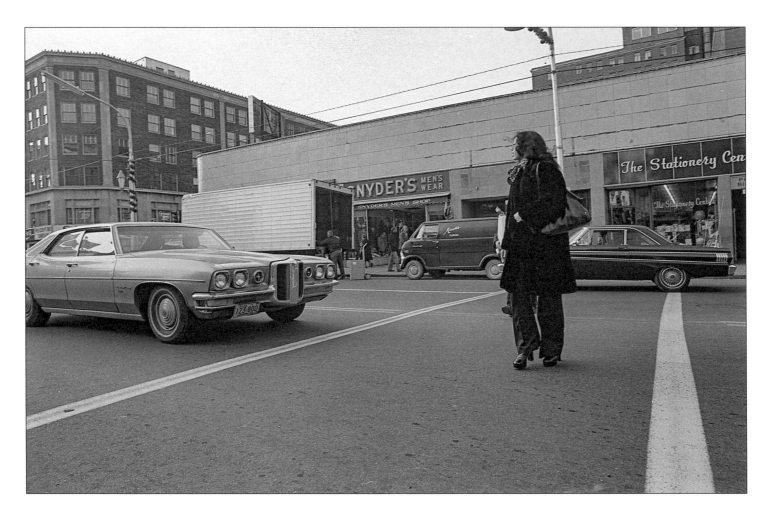

A woman stares at a car as she crosses the street. You can see Pine Tree Billiards and Snyder's Men's Wear in the background. This plaza, which once included the infamous all-night Dunkin' Donuts, was torn down to create Congress Square Park.

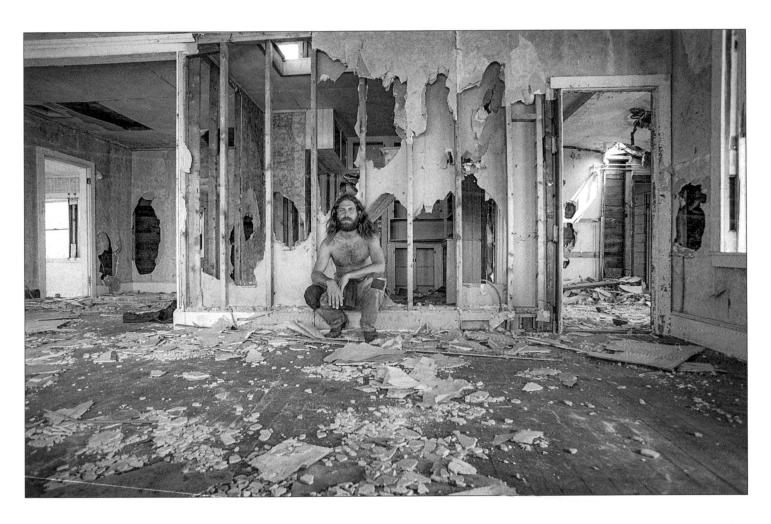

This is a self-portrait in a crumbling house on Long Island in Casco Bay. I set the timer on my Canon and dashed back across the room. I think it was a metaphor for my state of mind at the time.

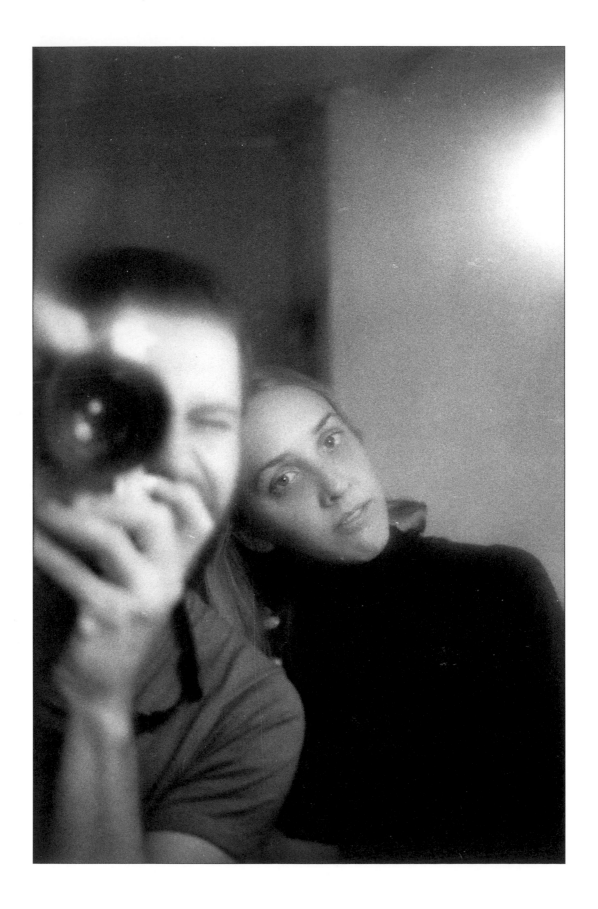

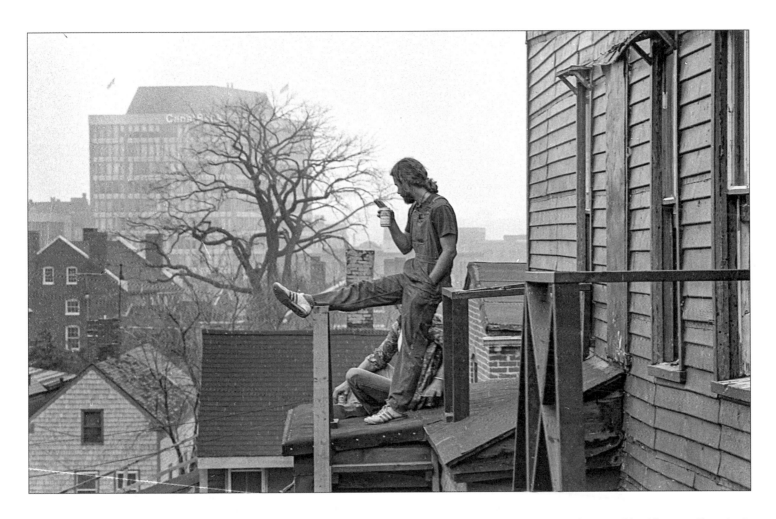

ABOVE: That peaceful, easy feeling. Enjoying a drink and a view of downtown Portland. OPPOSITE: June and I taking a self-portrait in the mirror inside her apartment.

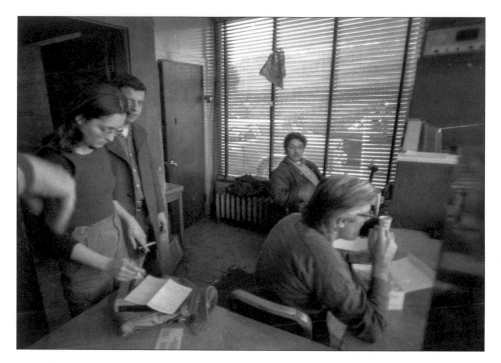

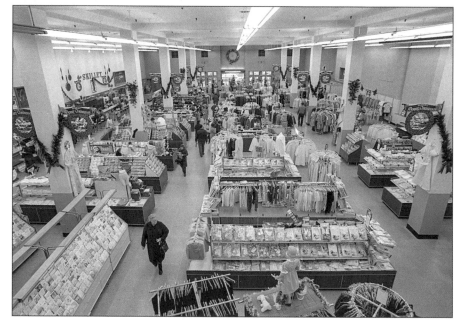

ABOVE, LEFT: Inside the Yellow Taxi office on Forest Avenue. That is Nadine on the left. ABOVE: John Read LEFT: The inside of the W.T. Grant's store on Congress Street. I washed dishes at the nearby Woolworth's store. I worked in the basement and the dishes were sent back and forth via a dumbwaiter.

OPPOSITE: Jeanne Titherington, who graduated from Falmouth High School with me in 1969. Jeanne became a children's book author and illustrator. Her books include *Pumpkin Pumpkin*, *A Place for Ben*, and *Baby's Boat*.

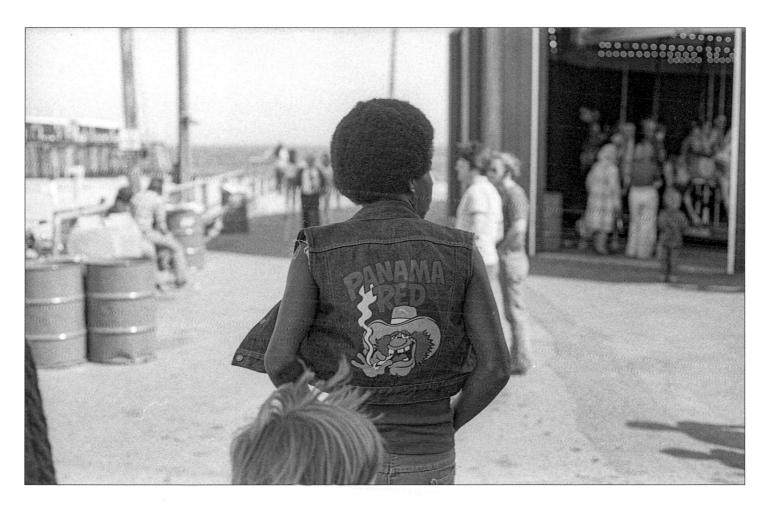

ABOVE: "Panama Red" walking along Old Orchard Beach. OPPOSITE: One of our Portland friends, looking very seventies, at the corner of High and Danforth streets. This picture later appeared in the *Portland Press Herald*.

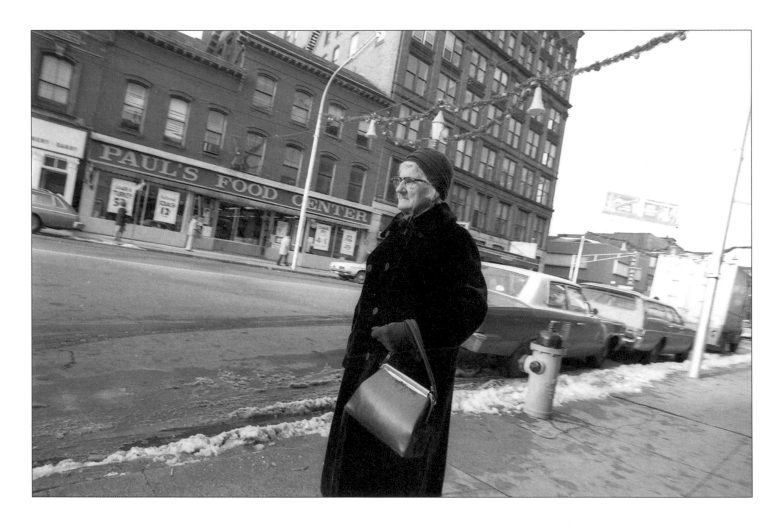

A woman on Congress Street, probably waiting for a cab. I often parked my cab near Paul's Food Center to hang out or wait for a fare. Paul's was started by Paul Trusiani in the 1970s and was a great place to get groceries and supplies downtown for about forty years. It closed in 2016.

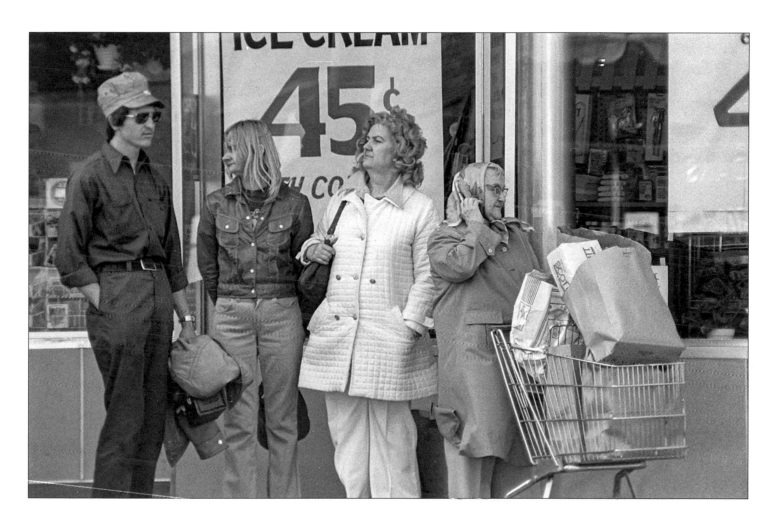

Folks waiting outside Paul's Food Center on Congress Street. I am sure I was in my cab at the time I took this. In the seventies, people still did a lot of their regular errands downtown, such as shopping for groceries.

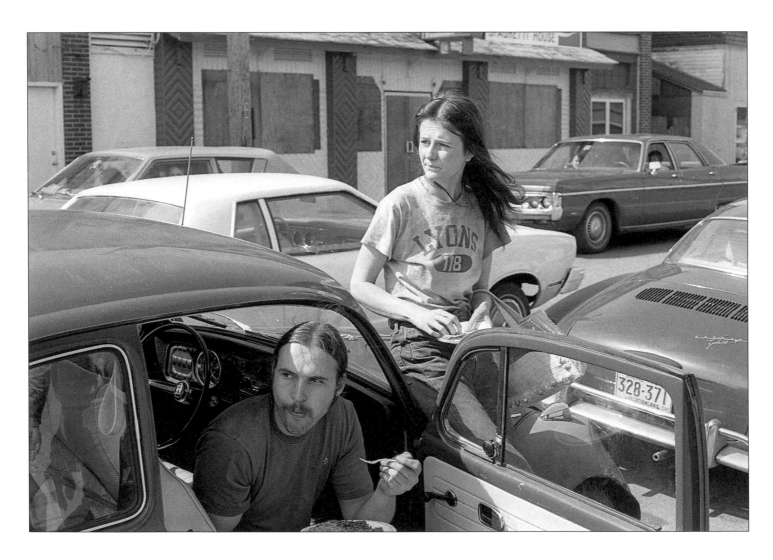

ABOVE: Brad Blanchard and Angie Daucher, who later got married, getting some lunch in Old Orchard Beach. Later, Brad worked as a physical therapist, including at Scarborough Family Physical Therapy, and Angie studied art at Portland School of Art. They are still together. Makes my heart sing! OPPOSITE: A young girl sitting against the Libby Building at the corner of High and Congress streets. I love to wonder what she was mad about or if maybe she was just sitting there bored on a summer day.

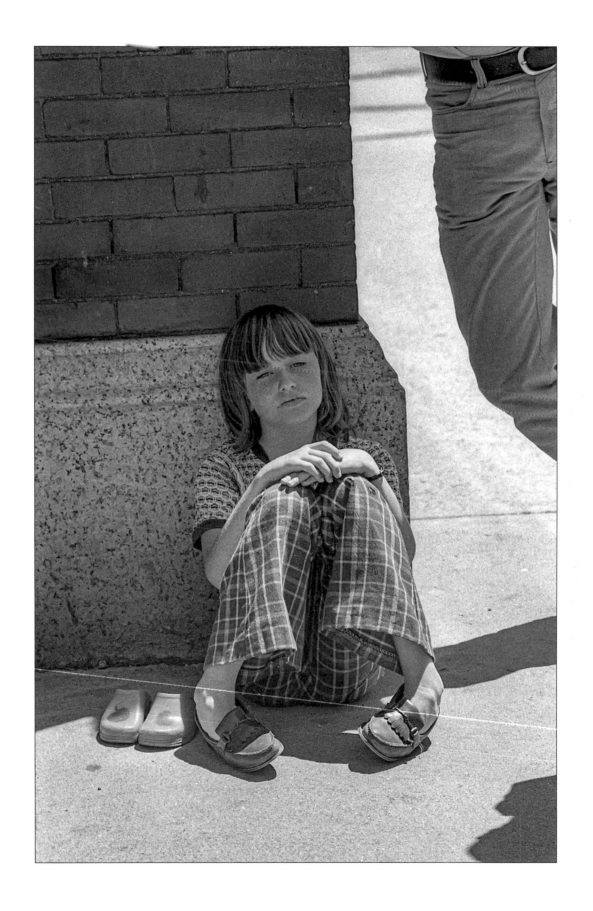

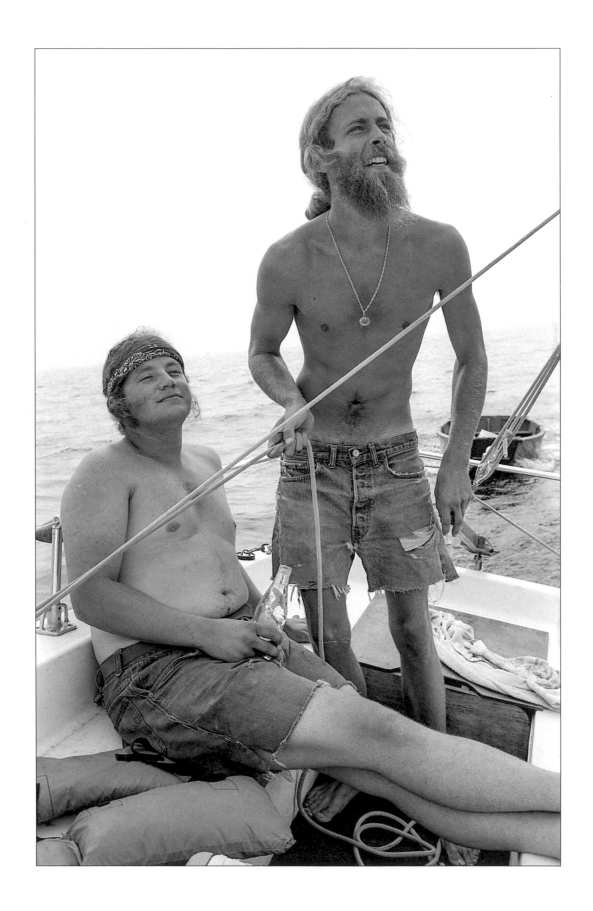

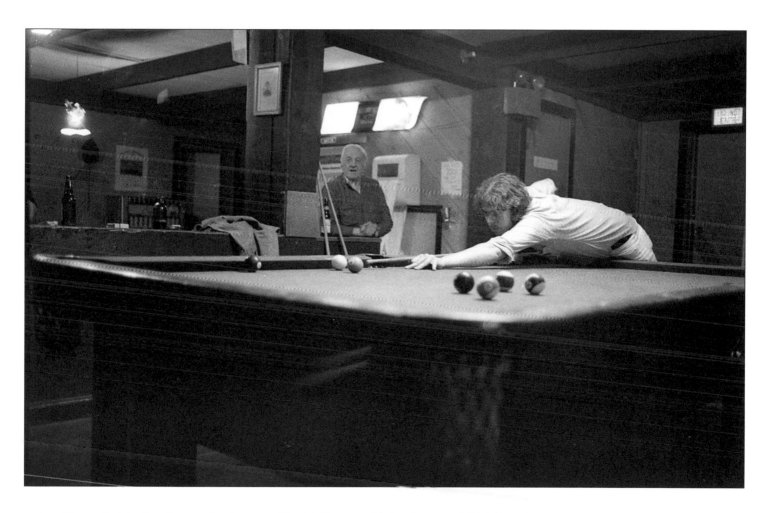

ABOVE: Roger Sabin shooting pool. OPPOSITE: Martial Mason, with the beer, and Dick Wood on Dick's boat in Casco Bay. Martial lived in Falmouth and his father was the superintendent of Falmouth schools. His brother, Robin, was in my high school class. Dick was a backhoe operator and died after falling off a stone wall during a break from building a horse shed in Casco. He fell backwards off the wall and broke his neck.

Watching the sunrise on the beach after partying at an all-night Disco Night. That's Sandy Boivin, on the right, with a friend.

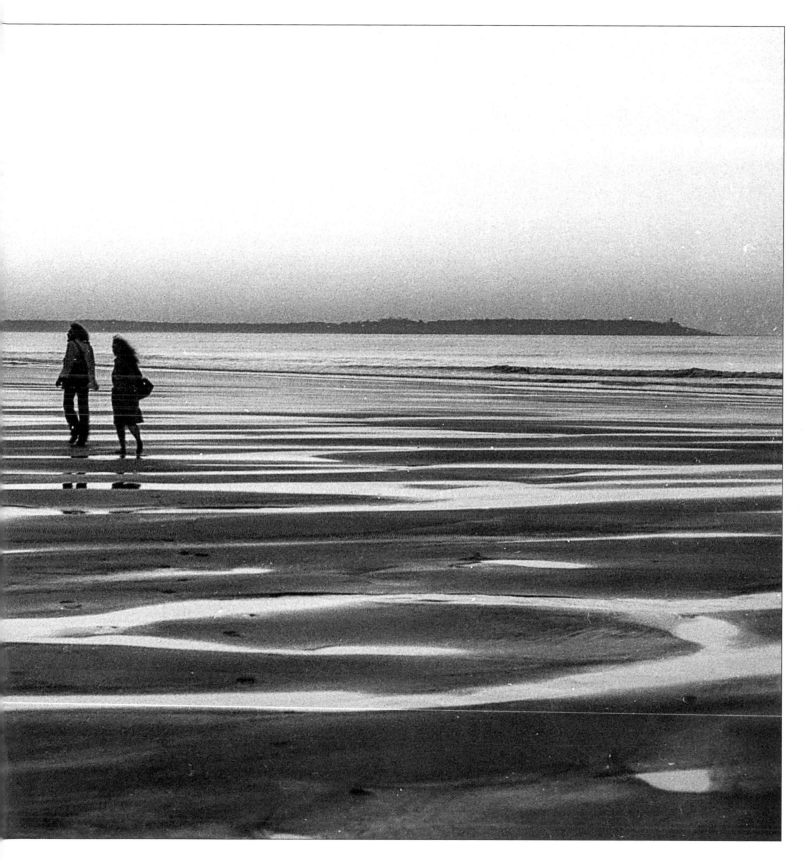

Acknowledgments

Photo by Dave Dostie.

First and foremost, thanks to my wife, Susanne, and my sons, Joel and Leo, for putting up with my obsessiveness when it comes to my photography. Nick Gervin, an amazing photographer, for reaching out and encouraging me to put my work into the public sphere. Marty Eisenstein, for helping me understand the legalese, when it comes to a book contract. Chad Conley, for his support, and permanently displaying my work on the walls at Rose Foods. Jack Milton, former photo editor at the *Portland Press Herald*, for all his encouragement and support. Bonnie Blythe, and the Portland Encyclopedia 60s, 70s, 80s Facebook page for providing a space for myself and others to share their stories. Troy Bennett, for his front-page story in the *Bangor Daily News*, which opened the door to new opportunities. Chris Busby, for using my work in his publication, *The Mainer.* His encouragement and support is very much appreciated. Shaun McCarthy, owner of the Dock Fore, for his support of many local artists, myself included, in his pub in Portland's Old Port. Dave Dostie, an outstanding photographer, who photographed me for the book. Getting to know him has been such a joy! Erik Messerschmidt, son of longtime friends, and Academy Award-winning cinematographer, who, when we last met a few years ago, praised my work, which helped my confidence level immensely! The Bakery Photo Collective, for always accepting my work as part of its annual fundraiser, Photo A Go-Go, at Speedwell Projects. Lastly, Dean Lunt, Genevieve Morgan, Teresa Lagrange, and everyone at Islandport Press, for guiding me through this process, and their encouragement, support, and tireless efforts. Without them this book would not be possible.